Carving
Miniature
Carousel Animals

Country Fair Style

by Jerry Reinhardt

The Vestal Press, Ltd.
Book Publishers and Distributors since 1961
Vestal, NY 13851-0097

Dedication

This book is dedicated to some of the best woodcarvers in the world, those old woodcarvers that created the magnificent American wooden carousels...

and to

Marilyn,
my partner in everything

Credits:

Illustrations:	Jay Reinhardt
Phtographs:	Jerry Reinhardt - black and white
	Bruce Veatch - color and black-and-white printing

Library of Congress Cataloguing-in-Publication Data

Reinhardt, Jerry,
 Carving miniature carousel animals: country faire style / by Jerry Reinhardt.
 p. cm.
 ISBN 1-879511-22-3
 1. Miniature wood-carving – Patterns. 2. Merry-go-round art. 3. Animals in art.
 I. Title
 TT199.7.R453 1996 96 – 1573
 736'.4 — dc20 CIP

© 1996 The Vestal Press, Ltd.
All rights reserved
Printed in the United States of America
First printing 1996

Table of Contents

Introduction

Life is funny sometimes. At least mine has been. Never in my wildest dreams did I ever think I would be carving carousel horses or writing a book about carving them. I have only been involved with carousels for the last 15 years or so. But I'm having so much fun that, I wonder why it took me so long to discover them.

I started carving as a kid. But I used to carve things to play with, like wooden guns, knives, and solid model airplanes, because there were no plastic toys then. For those of you too young to remember, we used to have stores called "dime stores." In these stores you could find wonderful model kits. Each kit would come in a cardboard box with a set of plans and three or four pieces of wood. You could spend your whole summer whittling the wood into the desired shape, airplane, ship, whatever appealed to you most. I liked carving airplanes best at that time. There was a notice inside the airplane kit box that said that if you wanted to send your finished airplane carving to the War Department, they would use it for training pilots to recognize various aircraft —- friend or foe. Thank goodness the war ended before I carved anything recognizable as an airplane. I thought of those early airplanes of mine when I became a navy pilot later. That was during the Korean War, and the opportunity to learn to fly was too much to resist. I didn't even carve at all then. In fact, I sort of quit carving when I discovered girls. There are only so many hours in a day! I got married to one of those girls as soon as I earned my navy wings. Her name was Marilyn, and we have been married now for over 40 years. She has been a real jewel and has traveled all over the world with me. (We spent 23 years in the navy.

I was a flight instructor in Corpus Christi, Texas, when our son, Jay, was born. We took him back to Kansas to show off our fantastic accomplishment to the folks back home. During our visit, I met the father of one of Marilyn's friends, in Lindsborg, Kansas. His name was Anton Pearson and he was a wood carver. He had immigrated from Sweden, and carved mostly old immigrant-looking Swedes. I watched him carve for about three hours one afternoon. It fascinated me. When I went back to Texas, I dug around, found my old carving tools, and started carving again. I tried funny-looking characters first, but I never could duplicate Anton's unique carving style. I have been carving ever since.

I didn't find any more woodcarvers for awhile. But when we lived in the Philippine Islands for two years, I discovered wood-carving villages in Northern Luzon, not far from Baguio. The people were just barely out of the head-hunter stage and didn't wear many clothes, but they made beautiful carvings of things like water buffalo and self-images of one head-hunter holding another's severed head. They used their feet to hold the carvings while they worked. Their chisels were made from the leaf springs of old cars. They used a rope with a treadle board to stand on to clamp their larger carvings in place. A rope was stretched across the carving. One end of the rope was attached to a long board. The carver would stand on this board (the treadle-board) to tighten the rope and thus hold the work-in-process steady. To change the position of the wood, they would hop off the treadle-board, adjust the wood's position, and hop back on again to clamp the carving tight once more.

At the time, I remember feeling sorry for

the Filipino carvers, not having any modern tools or clamps. It wasn't until much later that I discovered that a rope and treadle board is an ingenious way to clamp an oddly shaped piece of wood in place. My work bench has two small rope clamps I use sometimes in a similar way. (See figure 1 which follows.) This method works on large carousel horses, too! Our daughter, Joni, was born while we were in the Philippines.

much opportunity to carve in the gun tubs because we flew almost around the clock, but it was the most relaxing thing I could do to pass away the free time I did have.

I was in my first woodcarving show in 1971 in Bonn, Germany. I was a naval attaché assigned to the Embassy and the show was an exhibition "art show by diplomats." My only competitor was a Russian. He carved very modern-looking stuff and my piece looked

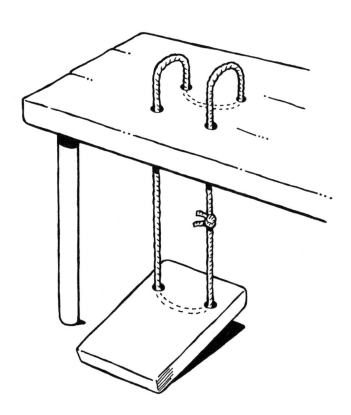

figure 1 Illustration of a treadle board

Carving was a good way for me to relax. I carved just for the fun of it. I used to sit up in a gun tub and carve when I was flying off the USS Bennington during Vietnam. For those of you not familiar with gun tubs, a gun tub was a large armored "tub" that provided some protection to the gun crews manning the guns located in the center of each. The Bennington had two five- inch guns on each side of the flight deck as well as some rapid fire cannons. All were located in gun tubs. I didn't have too

rather primitive by comparison —- two old guys playing checkers. But it was a start!

Marilyn started giving my carvings away about this time. (The house was getting too cluttered up.) I feel sorry for those poor people who were the recipients of those early carvings. They were pretty bad. We never heard from a lot of those people again —- after they had received a carving!

After I retired from the Navy in 1975, I started a contruction company and built

houses for a while in Johnson County, Kansas (part of greater Kansas City). Each house I built had my trademark, something I carved, built into it. I usually carved the mantle block for the fireplace or the spindles of the stair rails. Sometimes I carved the doors of the kitchen cabinets.

We joined the Kansas City Woodcarvers Club and the National Wood Carvers Association. These organizations served as great places to learn about carving. I hardly knew any other woodcarvers until we joined those groups. I discovered from them that woodcarvers all share. There are no secrets. The best sources for wood, tools, and carving techniques are all shared. I feel that I never would have been able to learn, on my own, what those 200 or so woodcarvers shared with me and taught me.

In 1979, the KC Woodcarvers decided to get a booth at a new event starting up in Bonner Springs, Kansas —- the Renaissance Festival. We all were going to dress up in funny pants and hats to man the booth and sell our carvings on weekends. The problem was that everything displayed or sold had to be from the Renaissance era. I researched that era in the Encyclopedia Britannica and discovered most of the art at the time consisted of Michelangelo nudes or religious figures. That just wasn't my cup of tea. Then I discovered that carousels started during the Renaissance. I knew what a carousel horse looked like. I carved a couple of horses, poked a pole through them, and they SOLD. I sold out the very first weekend. I had to go back and carve more to sell the next weekend (which was not easy as I was still building houses). A guy walked up to me and asked if I could carve a *real* carousel horse from a picture. By that time, I had carved four of my own design and knew everything there was in the Encyclopedia Britannica about carousels, so I said, "Sure!"

He used that carving on a display for a carousel manufacturer, at an International Association of Amusement Parks and Attractions convention show. Alice DeCaprio, a carousel artist who also had a booth at the show, saw the display and contacted me to carve horses for her customers.

This was the beginning of a whole new world for us. Alice became a special friend and dragged me kicking and screaming to the next IAAPA show. (I argued that I didn't have time for this nonsense.) But I sold out all of my carvings in just a few hours. Alice also convinced me to join the National Carousel Association. We went to our first convention of the NCA in 1983 in Providence, Rhode Island and have not missed one since. It fascinated us. We also joined the American Carousel Society and several carousel support groups around the country. Later, I became a director of the National Carousel Association.

Orders for miniature carousel horses started to pour in from all over the country. This attention was all due to word of mouth; I didn't advertise. I didn't really want all of those horse orders. I was still trying to build houses. Things were starting to get hectic. We had almost a six-month backlog on orders for horses. I was building houses during the day and trying to carve and paint horses at night. The problem was that every time I carved a horse and sent it out, I got two orders back! There was no way to keep up. I tried raising the prices but it didn't help. I was still buried in orders.

About this time, Marilyn started to help me out by painting the parts of the carousel animals that were not too difficult. (She had never had any art training and didn't know anything about painting on wood.) She did a pretty fine job. Soon, she started tackling more difficult parts of the painting process and I discovered *she* was better at it than *I* was. She became the permanent painter.

Someplace along the line, mortgage rates went out of sight and people stopped buying houses. We hardly noticed. We were so busy carving and painting carousel horses that it was hard to worry about things like that. We

changed the name of the company to "Carousel Woodcarvings," a division of Reinhardt Construction Company, and just kept going. I haven't built a house since.

About the time we had piled up a backlog of one year on orders for carousel animals, we decided we might be able to ease the load if we had molds made of the carvings and sold castings of them at a lower price. The idea was that people would then want the castings rather than the actual carvings. The idea backfired! The castings sold —- but now we got orders for *more* castings, *as well as* the carvings.

The only solution was to carve faster and as efficiently as I could. I tried every trick I could think of to increase my speed without sacrificing quality. I tried teaching woodcarving for our local junior college because I knew that when I had taught flying while I was in the navy I had become a better pilot. The same principle applied to woodcarving. If you teach someone else, you become better. When you start thinking about how and why you do things a certain way, you start to improve your own methods quite a bit in the process.

Anyway, an article about Marilyn and me came out in the January, 1994 issue of Wood magazine. After that, we were literally buried in mail requests for information about how we do what we do. Our mail lady started to complain that our mailbox wasn't big enough. Harvey Roehl of the Vestal Press showed up at my door one day and convinced me that the real solution to my problem of answering all the questions and inquiries was to write a book.

So, I have written down everything that I have learned about carving carousel figures that I can think of, in this book. But this is only part of the story. We have barely scratched the surface with the few patterns in this book. I have carved over 1,000 carousel figures at this time, from several hundred patterns I have drawn. Almost all of them were made from photographs I took of the actual carousel figures. So, in this book, I started with the trav-

eling merry-go-rounds. This is the beginning, and I hope it tickles your interest. If so, more books will follow.

Many people have helped me get this far. My son, Jay, helped by adding his humor with his cartoons, his artwork, and illustrations. Bruce Veatch, my photographer-neighbor, helped me with my photos by giving me ideas on how to improve them. He also did all the developing and printing of the black-and-white photos and did the color photography. Marilyn, my partner for life in all my endeavors, had the worst job of all. She had to put up with me and the mess I created with photos, drawings, and pieces of paper all over the place. She also was the one that had to read the early drafts and critique me without damaging my ego. We almost had a fight over the "how to paint a carousel horse" section. She didn't like what I had written. (She won!)

Anyway, I want to share the result of these efforts with you, just as so many people have shared with me. We have carousel friends all over the country now —- and in other parts of the world, too. We gather at carousel conventions, whoop and holler a little bit, photograph carousels, listen to those fabulous old band organs belting out songs you can whistle to, ride on our favorite carousel animals as if we were kids again —- and put our hands on some of the most fantastic wood carvings ever created —- the American carousel figures.

Life is funny sometimes. How did I ever get from wanting to fly airplanes as a kid to carving carousels as an old geezer? We are still as busy as ever and having a ball.

Hope you enjoy this.

Have a Merry Go Round Day!!!

Jerry Reinhardt

Chapter 1

ALL ABOUT CAROUSELS

Everyone knows what a carousel horse looks like. They remember their first ride on a carousel as a kid, how they tried to pick out the prettiest horse or the fastest, or the one that went up the highest. Or else they remember taking their own kids on the carousel and watching the excitement on their children's faces as they experienced that first wild ride. So everyone ought to know all about carousels. Or at least they ought to know what a carousel horse looks like. But do we?

A carousel horse is <u>not</u> just a carved horse with a pole poked through it (like the first one I carved!). It has special sizes and shapes and is completely different from that familiar horse standing out in the pasture. The carved carousel horse is a work of art, a beautiful woodcarving designed to catch your eye and entice you into purchasing a ticket to ride on that spinning machine filled with music, fantasy, and delight.

A carousel horse was made to be flamboyant, yet practical. It had to fit into a particular position on the merry-go-round and it had to carry large numbers of people, most of whom had no respect for the artistry of their mount. It had to be tough. It had to be engineered to stand up to the elements as well as the stress of the many careless little hands and feet which seemed determined to destroy it.

There were about a dozen well-known manufacturers of carousels in America. They operated at different times between the years of the Civil War and the Great Depression, roughly between 1867 and 1930. Most of the carousel factories were on the East Coast. Gustav Dentzel is credited with starting the

first factory in Philadelphia in about 1867. Most of the factories were concentrated in Philadelphia, New York City, and Tonawanda, New York. Later, some smaller companies sprang up throughout the Midwest, and Charles Looff moved his operations from the New York area to Los Angeles. C.W. Parker had a major enterprise which started in Abilene, Kansas and later moved to Leavenworth, Kansas in 1911. Most of the carnival carousels written about in this book were manufactured at the factories in Tonawanda and Kansas.

In America, all carousels were made to turn only in a counter-clockwise direction. That meant that as the carousel turned, an observer would see only the right side of the carousel animal as it spun by. Therefore, the carvers of these animals put their best efforts into carving that side of the animal visible to the observer —- the right side. In carousel lingo, this is called the romance side. The left side, or the inside of the animal was left very plain, with only a little carving on it. Many horses had jewels mounted in their harnesses to catch and reflect the lights. Normally, these too were placed only on the romance side, the chest, and the rump. Usually, the inside of the animal was not decorated with jewels.

The outside row horses were always the biggest and fanciest and boasted the most elaborate carvings and designs. The inside row horses, less easily seen by the observer, usually had nicely carved heads and sometimes were decorated by carvings on the chest and rump where they could be seen easily. But the inside horses had less carving and fine details than the outside row animals. That kind of detail would

have been wasted as it wouldn't be seen. Along with this way of thinking, the heads of the horses were normally turned to the right, and most, if not all, of the horses' manes were on the right side of their necks. Thus the animals were designed and executed to provide the most appealing view to the observer outside the carousel.

Most carousels had one horse on the machine that was fancier than the rest or that stood out because it was different from the others in some special way. This figure was called the "lead" horse. The lead horse had a purpose. It was there that the ticket-taker started and ended his collection for each ride.

There were "park" machines and traveling portable carousels. The park machines were usually much fancier, with more elaborate carvings than those on portable merry-go-rounds. They were usually located in a permanent amusement park, enclosed in a structure, and were usually larger in diameter. Park carousels also normally had more figures mounted on them; there were usually three to five rows of carved animals. Some of the bigger park machines sometimes carried 80 or more figures. Often, the outside row was made up of all "standers." A stander is a figure that normally had at least three feet supporting the figure mounted on the platform and did not move up and down on its pole. The standers were the biggest animals on the machine and had the most ornate trappings and embellishments of any of the figures. The standers were the woodcarvers' showpiece figures.

The traveling carousel was usually seen in the carnivals that visited the smaller towns. Wear and tear on a portable carousel was much greater than that on the park machines because of the way they were operated. They were often set up, taken down, packed, moved by train or truck, and set up again several times a week. For this reason, they were usually smaller

in diameter than the park machines. There were only two or three rows of animals and the animals were not as elaborately carved.

The actual size of each carousel animal varied with the overall size of the merry-go-round itself and the particular row on the machine where the animal was placed. Each row of figures on a carousel had to fit on a wedge-shaped platform that looked like a piece of pie with

figure 2 : American carousels turn counter-clockwise. Carousel figures were mounted on a platform shaped like a piece of pie. The largest carvings were on the outside near the "crust."

the tip bitten off. A horse on the outside, or near the "crust" of the pie, would be bigger than one near the inside of the pie near the tip (as shown in figure 2, above). Sometimes, the position of the legs and head would indicate whether a horse was an outside or inside row horse. The outside row horses had more room to stretch out, while the inner row animals usually had their legs tucked more closely under their bodies.

While most carousel figures were horses, many carousels had figures riding on them that were not horses. Almost any animal you can think of has been carved and put on a carousel. If a machine included animals other than horses, it was called a menagerie carousel. Some of the menagerie animals found on carousels are not so easy to recognize. I think some of the carvers were carving animals they had never seen before; sometimes even figures that no one had ever seen before. But these figures add interest and variety: kingly lions, sea monsters, colorful ostriches, roosters, stately giraffes, and humorous frogs dressed up as footmen. I will deal more with these animals in a later book.

Almost every full-size carousel figure ever produced was approximately *one foot* wide, no matter where it rode on the carousel. If you looked down on a carousel animal, from a bird's eye perspective, it looked almost slab-sided, with very little shaping, and each animal a maximum width of one foot. Some kiddy horses and inside row horses would be smaller and a few menagerie animals like lions, or the rare elephant, would be wider.

Most of the wood used in the original carousel figures was linden (basswood). It was lightweight, strong, carved beautifully, and it was a wood that most of the immigrant European carvers were familiar with. Many of the original carousel carvers were immigrants from Europe. There they had generally carved in European linden, so the American linden was naturally sought out for its familiarity. The notable exception to this was that many of the horses carved in the New York area, especially in Tonawanda, were carved from poplar, because it was a more readily available local wood.

The original carousel figures were assembled from many pieces. This saved a lot of wood, gave greater strength to the figure, and

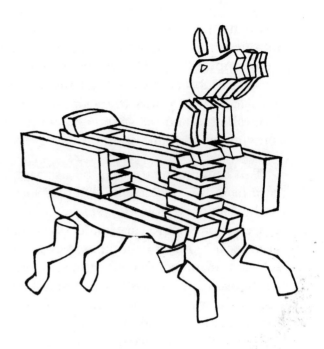

figure 3: Carousel animals were assembled from many pieces of wood. The body was a hollow box, with legs, head and neck added on.

was a faster process than carving the entire figure from one piece of wood (See figure 3 at right.). It also made the finished carousel horses lighter because the bodies were made into a hollow box, thus saving many pounds of weight per figure on the carousel.

Carousel horses were assembled by crews of workers in carousel factories. Individual parts were cut out on huge bandsaws from standard patterns and put into storage bins. As orders were received, the proper parts were retrieved and assembled. The designs of the saddles and the decorative trappings were sketched on and carved, usually by young or apprentice carvers. The chief carver of the crew carved the head and mane areas, the most critical and important part of the carving. He was called the "head man." Perhaps this was the origin of that term in our American slang.

The same basic patterns for carousel horses were often modified to create a completely different "look" to a carving. Often, the same

3

silhouette pattern was repeated on a carousel, but due to the different carving and design of the trapppings, and different paint colors, etc., the casual observer would not recognize that fact. All they saw was the swirl of color, the flash of lights, and the sparkle of all the jewels as the merry-go-round spun by.

This same technique can be used with the patterns in this book. Many different variations can be fashioned from the same silhouette pattern, each one fun to carve in its own right. Let me offer a word of caution, however. Each of the major manufacturers of carousels had a certain "look." It wasn't just in their silhouettes or patterns, it was in the way they designed their trappings and decorations. If you vary them too much, the finished carving won't have the real "look" of an authentic carousel horse. Hints on how to maintain the specific "look" of a particular manufacturer will be included in this book.

There were many different manufacturers of carousels. Some were large and some small, but each had his own individual designs and special look. Each manufacturer was trying to create the best carousel he could for the least amount of money. Each wanted a piece of the entertainment market. Many manufacturers failed after a short time, or during periods of economic depression. Their workers and carvers had to look for similar work in other factories. Woodcarvers and designers of carousel figures often crossed over from one company to another, bringing their own particular carving style to each company as they went. Therefore, there is very often a blurring of differences or a new or changing look in the way the horses were produced by a particular carousel company.

Some companies carved only replacement pieces for worn-out or broken carousel figures, usually only a few figures at a time. Sometimes, entire carousels were sent back to a factory to be refurbished. They often had newer replacement carvings put on to replace the worn pieces. Therefore, carvings from the same company from different time periods could be on the same machines and so it is possible that they, too, might have different looks. Also entire carousels were sometimes traded to a different manufacturer for a new carousel. That manufacturer would then save any usable carousel figures and put them back on the next carousel they produced.

Most of the carvers in the New York area once worked with Charles Looff, the founder of the Coney Island style of carousel figures. So, Illions, Carmel, and Stein/Goldstein all had similar backgrounds and took some of the Looff characteristics with them when they left and started their own carousel companies. Carmel and Looff are exceptionally close in their look and style.

So, you may notice that, sometimes, when you look at a carousel spinning by, you may find that something may catch your eye that doesn't look quite right. It may be that a strange beast rides the carousel that looks a little different and doesn't fit in with the other figures. It may be that it was carved by a different company or carver than the others. Today, there are not many pure machines left. But that is okay. It doesn't detract from the value of the carousel. It adds flavor, maybe a little mystery, and a lot of interest and wonder to that part of the history and the beauty of what is the American Carousel.

Chapter 2

TOOLS NEEDED TO CARVE MINIATURE CAROUSEL FIGURES

I don't know of a woodcarver alive that has enough carving tools. I also don't know of any two carvers that have or use the *same* tools. Everyone has his own favorite tools and I have mine. That doesn't mean that yours won't work. It just means that you may not use the same tool that I do to do the same job or make a specific cut.

I have a couple of basic rules that I try to follow when I reach for one of the tools on my bench:

1. Use the biggest tool that will do the job. (That eliminates having to make several cuts, and usually produces a smoother carving with less tool marks.)

2. If the tool doesn't cut right because it is dull, stop right then and sharpen it before you complete the cut. You will find this saves a lot of time in the long run and also saves you from picking up the same tool later and finding that it still doesn't cut right.

figure 4: My carving bench with its mess of tools

Now I have a lot of tools (as you can see in figure 4, on the preceding page). But I start drooling every time I get around new wood-carving tools. I am always looking for that tool that is going to make me a better carver. I also have a lot of tools I never use. Usually, they are of poor quality steel, or some strange shape that I can never find much use for.

TOOLS I ALWAYS USE

Bandsaw

Every woodcarver needs a bandsaw. I use mine almost every day to cut out blanks. A blank is a shape cut from a block of wood, and is usually just a silhouette of the figure to be carved. Using blanks saves *hours* of chopping out a wooden shape from an entire block of wood and allows you to get to the real carving sooner (which is, after all, the fun part!).

I use a 12-inch, 2-wheel bandsaw. I some-times wish I had a 14-inch saw, but I can make do with the 12-inch. I always cut out my blanks using a 3/16-inch, 4 tooth to the inch, skip tooth blade. That size blade will turn inside most of the cuts you will have to make. I try to cut flush up against, but just outside of the line of the blank as I am cutting it out.

Coping Saw

A coping saw will help you remove the wood between the legs quickly, as part of the roughing-out procedure. I set my saw up to cut on the pull stroke. It saves a lot of broken blades.

Gouges

I have lots of gouges. I have gouges in sizes from tiny palm tool gouges up to gouges so big they have to be driven with a mallet. I begin all my carvings using gouges to rough-shape the blank.

I like relatively flat gouges of all sizes to work the wood down. I also have several deeper gouges for digging and hollowing out. I have many identical gouges of different shank lengths.

When you are always trying to work between legs and under tails, you will find that where one length will work perfectly, the same sized gouge with a different shank length will not.

V-Tools

I use almost as many V-tools as I do gouges. They are the parting tool that separates the trappings from what is the body of the horse. They define the details and create decorations. Most of the time, I use 90-degree V-tools, but I also have a few 60-degree tools that I use to undercut and to create shadow. I use both palm tools and hand tools, which-ever works best on

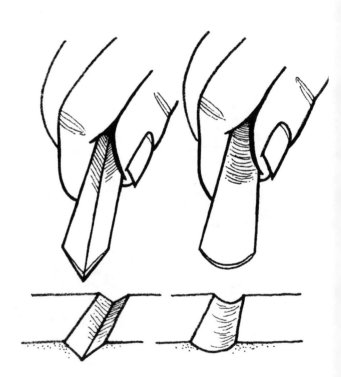

figure 5: Gouges (on the right) are for moving wood. V-tools define and separate details.

By laying a V-tool on one side and carving around an area to be elevated, you create a shallow trench with one almost vertical side. Then you shallow out that trench even more by feathering the wood away with a skew to create the lower level (as illustrated in Figure 6, at left.)

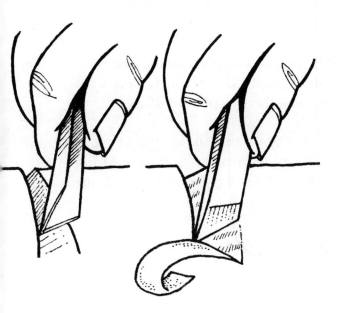

figure 6: A skew is used to flatten the surface behind a V-tool cut, to create the illusion of a lower level. (V-tool, left and skew, right.)

the particular project as I am working (and whichever happens to be the sharpest at a particular moment, or whichever tool I happen to pick up first!).

There are no hard and fast rules about V-tools. Just use whatever works best for you for a particular job at a particular time.

Skews

Skews are my newest discovery. The more I use them, the more I like them. They always slice as you cut, so they cut cleanly. They are just about the easiest tool there is to sharpen, and I use them for smoothing out tool marks. They are especially useful in creating levels on a carving, i.e., to make the saddle appear to be on top of the blanket, or the blanket on top of the horse. They help to create the illusion of different layers, i.e., the blanket going underneath the saddle.

figure 7: Most often used push tools.

Carving Knives

I have a bunch of these knives. They all have different blades, but most of them are in a big handle that I designed specifically to fit <u>my</u> hand. I have found that using a skinny handle for very long makes my hand tired. I can carve all day with a big handle, because I don't have

7

to squeeze the handle so tightly to hang on to it. Most of my knives also have flat sides so they don't roll off my bench. The most important factor in choosing knives is that they fit and feel comfortable in your hand.

Now, if you don't have a lot of these tools already, you can probably get by with what you do have. You will find that you will just have to improvise as we all did when we started out. The only hard and fast rule of thumb I would offer is to stay away from cheap tools made with poor steel. In the long run, this practice never pays off. Find something you like that holds a good cutting edge, and then buy whatever else you need as you can afford it.

Color Coding

The fact that I have so many tools, compounded by the fact that I am a somewhat messy person, usually means that within an hour of the time I start carving my tools are in one big pile in front of me on the carving bench. Then when I start to look for a particular tool, I can't find it in the mess. My solution is to color-code each tool with acrylic paint. I paint bands of color around every handle. My V-tools are all different shades of red; my gouges are blues, greens, and yellows; and the skews are painted in shades of brown. Then, all you have to remember is what color the tool you want is painted, and it makes it a lot easier to find the right one. After using your color-coded tools for awhile, you start to remember which are which pretty automatically.

Mallet Tools

I use a mallet and some large tools for roughing out and to clean out the wood between the horse's legs. Mallet tools are not necessary; the job can be done with smaller hand tools. But it is quicker and easier to use the mallets. I use a deep gouge with a long shank exactly 1/3 of a inch wide to clean out between the legs of most blanks.

But be careful! Using a mallet is a quick and easy way to break a leg off, too. I use a light mallet and just tap the tool through the wood.

TOOL SHARPENING

I am not going to try to teach you how to sharpen your tools in this book. That would be the subject of a whole other book and there are already a lot of good books out there which address it. BUT, it is very important to know how to keep your tools sharp. There are many ways to sharpen tools and many sharpening systems available to help you. I believe there are probably about as many ways to sharpen tools as there are woodcarvers.

Most of the time, I use a 1-inch belt grinder (with an 80-grit belt) to re-grind a cutting edge and a cloth or leather buffing wheel with honing compound to hone my tools. I grind my tools very seldom, but I hone them often. If you get a good cutting edge to begin with, and simply keep that edge well-honed, you can keep a good tool sharp almost forever.

Very few new tools that you buy will come with a carving edge on them. You are going to need to sharpen whatever you buy. So, my advice is to learn how to sharpen your tools as early as possible and keep them as sharp as you can.

Chapter 3

JEWEL AND EYEBALL TOOLS

Most carousel horses were decorated with glass jewels that would add flash and glitter to a spinning carousel. (An exception to this was the carousel companies in the Philadelphia area, which did not use jewels on their original carvings.) The jewels came in all sizes and shapes. Some were square, some oval, and some triangular, but most were round.

Attempting to carve a tiny jewel on the side of a miniature carousel horse can be a problem for even the best woodcarver. So, I have either bought or made special "jewel" tools just for this purpose.

The easiest to find are those that can be purchased in most hardware stores. But in hardware stores they are not called jewel tools; they are called "nail sets." Nail sets are usually used by carpenters and woodworkers to "set" finish nails below the surface of the wood by driving them with a tap of a hammer on the head of the nail. Be sure that the ones you buy have a small hollow cup shape on the end of the nail set. (Some are blunt.) I have found them in sizes of 2/32, 3/32, 4/32, and 5/32 inch (manufactured by Stanley Tool Company). The size is usually stamped on the side of the nail set. I use the 3/32, 4/32, and 5/32 inch sizes most often.

One word of caution: *do not try to use any nail set that has actually been used to set nails.* The shape of the cup would most probably be damaged or misshapen and this would distort your carving.

By pressing the end of a nail set into soft wood, and twisting it back and forth, you can create a perfect small circle (jewel) and also burnish the wood so that it actually glistens. Try to purchase all of the different small nail sets you can find.

EYEBALLS TOO!

Almost all carousel animals had the same size eyes. Therefore, I made an "eyeball" tool for the scale that I work in, that is 6/32-inch in diameter.

I made my eyeball tool from a brass welding rod 1/4-inch in diameter, but other soft metal rods would work just as well, if you have them. You will need a piece 3 to 5 inches long.

Here are the steps for how to create an "eyeball tool:"(See the illustrations in Figure 8 on the fololowing page.)

1. First, make a drill jig. With a drill press, drill a 1/4-inch hole about 1 inch deep in a piece of scrap wood. (Take care that the hole is *absolutely* vertical.) Insert the metal rod you are going to use into the hole in the wood.

2. Using a metal twist bit, drill a shallow depression into the center of the end of the metal rod. This will help keep the grinding stone in place for Step 3.

3. Using a small round grinding stone, (Dremel has one), slowly grind a smooth, round, hollow depression into the end of the metal rod, not quite half of a grinding stone deep, until it is approximately the right size (6/32-inch).

4. Bevel the outside of the rod down to the outside edge of the depression so there is a pretty sharp edge.(I use a belt grinder.)

5. Insert the rod into a hardwood handle. Then test it in wood to see how it works — and what size it turned out to be.

6. If it isn't the right size, just keep trying until you get it right. And don't throw any of your attempts away! What you have created is actually another size jewel tool for carving your trappings, etc. I have some that are up to 14/32-inch, made from a 1/2 inch rod.

Now, if you have any machinist friends, they will probably laugh at this procedure. But if you do have machinist friends, why did you ever waste your time even trying this procedure yourself? Just ask your friend to make you a set of "jewel and eyeball tools" to whatever specifications you would like.

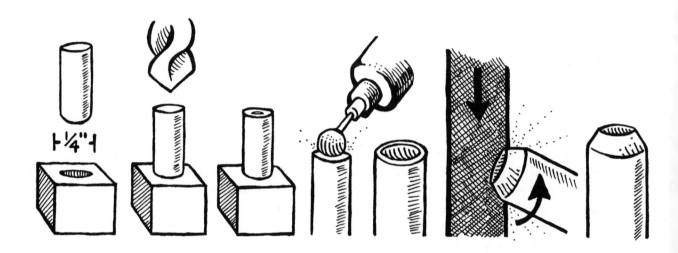

figure 8: Illustration of steps for creating an "eyeball tool" from a 1/4-inch brass rod.

Chapter 4

CARVING THE EYE

Carving an eye is not difficult. The eyes and eyeballs on almost any species of animal are all built just about the same. If you are not sure what the eye of a carousel horse looks like, just look in the mirror. Your own eye is an excellent model for study.

LOCATION, LOCATION, LOCATION

The major problem most carvers have is in placing the eye in the proper location on the head of the carousel animal. Now, a carousel horse's head is very similar to that of a real horse. At least, its eye should be located in the same place on its head as a real horse's would.

A horse is a member of the group of animals that are classified as "prey" animals or grazing animals. These kinds of animals are prey to those that hunt, that is, the meat-eating, carnivorous animals. Prey animals are structured so that their eyes are located at the widest part of their heads, which allows them to see behind them as well as in front of them without moving. Without turning his head, a horse can look back with one eye and see about 165 degrees behind the line of his head. (Each eye operates independently of the other. One can look backward while the other is in a neutral position.) A horse that looks directly at you can see you with both eyes and, therefore, has depth perception.

While the horse's eyeball itself is round, when it is enclosed in the eye socket and surrounded by the overlapping eyelid, it gives the appearance of a fat football. The upper eyelid appears to be the most dominant, partly because of its heavier eyelashes.

On all hunted animals (including carousel horses), the eye is located just below the widest part of the skull. If you drew a line through both corners of the eye (the pointed ends of the eyeball or "football"), one end would point to the nostrils and the other toward the base of the ear. The eyes are not slanted. They are not angled. A line through the two corners of the eye MUST point at the nostrils and the base of the ear. (See figure 9 below)

figure 9 (shows the correct eye position on head.)

The basic steps for carving an eyeball are as follows. A detailed illustration of these steps can be found on the following page in figure 10.

1. Sketch the eye in the proper location.
2. Undercut the upper lid.
3. Undercut the eyeball

11

4. Burnish the eyeball with your "eyeball tool"

5. Cut out triangles in each corner of the eye.

FIGURE 10: STEPS FOR CARVING AN EYE: WITH AN EYEBALL MAKER

(Step 1) With a pencil, sketch in the eyeball in the proper location. Then, using a small V-tool, carve the outline of the eyeball. (Step 2 and 3) Carve it in two cuts. Tilt the V-tool so that the upper eyelid is undercut. Make the second cut with the same tool so the eyeball is undercut. This will create the illusion of a more dominant upper eyelid. (Step 4) Burnish the eyeball you have created with your "eyeball tool." Use pressure. (Step 5) With a sharp pointed knife, cut out a small triangle of wood in each corner of the eye, which will give it the football look and also more depth. Round the eyeball over either with a series of small shaving cuts, or by burnishing with your special eyeball tool. (See the section on "Fashioning Jewels and Eyeballs" for details.)

Chapter 5

THE CARVING BENCH

It is important to have a good place to work and to keep your tools. I have gone through several evolutions of carving benches. When I was younger, I was in the navy and moved to a new location about every two years. I remember that in one of the places we lived, my work bench was a single 2 x 12, about three feet long, nailed up in one end of a storage shed. That was probably the worst work bench I ever had —- but, it was better than nothing. You need to have a work bench.

Now I think I have one of the best benches I have ever had. I still use the 2 X 12 sized boards, but now there are three of them placed side-by-side on a frame about eight feet long, with a window in front of it. Occasionally, I have to turn or change the front 2 X 12 because it tends to get scarred up from constantly working on it. I use the front edge of my bench a lot to steady the piece of wood that I am carving on. I also use a rubber bench mat draped over the front edge of the bench to keep from maiming the carving with some of the scars on the bench. I often like to carve standing up, because I can use the weight of my body to make the job easier, i.e., to push a gouge through the wood. I sort of lean on the carving tool, so I don't have to use any muscle at all. (If you find yourself having to use a lot of muscle while you are carving, stop and sharpen your tools!) I also have an adjustable swivel stool with a back rest that I can use when I am tired of standing.

But the most important thing I want to tell you on the subject of carving benches is that I read somewhere, a long time ago, that the most comfortable height for a work bench is 2 inches below your elbow height. So, whatever kind of bench you use, and whether you sit or stand at it, try to make the bench top approximately 2 inches below your elbow height. You will find that you are able to carve all day long without too much strain and it works beautifully. Now, I am tall so some of my shorter friends find themselves doing chin-ups if they come over to my shop, but it works for me and I don't get any backaches from leaning over a bench that is too low for me.

To give you a better idea of the set-up I have for my own carving bench, see the following page. Remember that this is just the way I have set up things for my height, convenience, space and use requirements, etc. You should set up your work area and carving bench to suit your own needs. Your work space should be comfortable and convenient for you to work in.

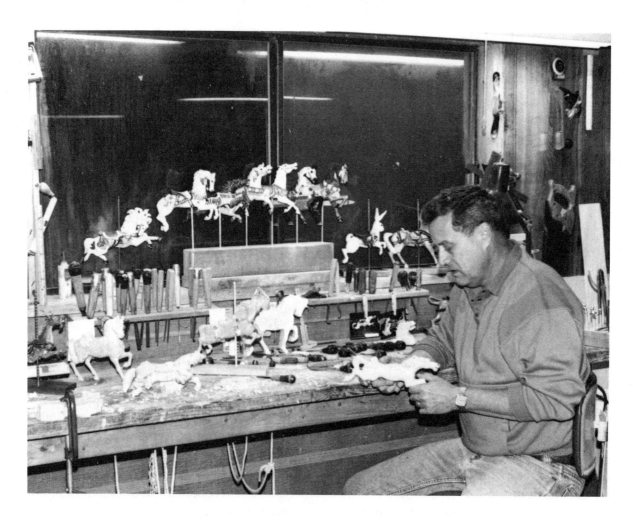

Figure 11: Here I am at work at my carving bench.

Chapter 6

C. W. PARKER CAROUSEL HORSES
1894-1925

C. W. Parker began his career in the amusement industry by purchasing and operating a shooting gallery. In 1892, he bought a portable two-row carousel originally manufactured by the Armitage-Herschell Company of North Tonawanda, New York. In 1894, he began making his own carousels, which were almost exact copies of the Armitage-Herschell carousels. Parker's factory was located in Abilene, Kansas. One of his earliest carousels, a 1901 two-row track machine, is still in operation today at the Dickinson County Heritage Center only 300 yards from the original Parker factory location. The horses are very simple perky-looking animals. The legs drooped more than on later models. The heads were erect and the ears were "lolly pop" pegs standing upright in the middle of Parker's characteristic wrap-around-the-ear manes.

In 1911, the Parker factory was moved to Leavenworth, Kansas, and the style of the Parker horses began to show radical changes. Parker primarily manufactured small portable carousels suitable for the traveling carousel, but he did produce at least five large park machines as well. The style of Parker horses shown in this book was first developed in about 1914, and was continued with very few changes until the factory discontinued making wooden carousels in about 1925. The horses produced during this era are the style most recognized as Parker horses.

CHARACTERISTICS OF A PARKER
HORSE (1914-1925)

1. The first impression of a Parker horse is that of a long body, with comparatively short, but stretched-out legs.

2. The mane and tail looked like twisted, pulled taffy or skeins of yarn. The mane frequently had peek-a-boo holes and the forelock was almost always parted in the middle and swept down and around both of the animal's ears. The tail was carved wood inserted into a socket in the rump. The tip of the tail was attached to the right back leg with a peg for added strength and stability.

3. The saddle was long over the body and "floating," i.e., the saddle seldom had a cinch carved on.

4. The head was long, with flaring nostrils almost as wide as the eyes. The nostrils were not very detailed, just scooped-out depressions. The eyes were glass, but sometimes had a white corner in each. Above the eye, an inverted V was carved to indicate an eyelid. Large teeth were prominent and the tongue was usually raised above the bottom teeth. The ears were laid back on the head and were carved as part of it. They were cone-shaped, with a simple gouged-out depression on the side. The bridle also "floated," with the end where the bit is never quite reaching the horse's mouth.

5. The trappings have a distinctive Parker "look." The same designs were consistently used, and were mixed on different figures which helped to create that look. Each Parker had a heavy chest and shoulder strap that widened to become part of the saddle blanket on the reverse side. The saddle skirt was often rounded like a copy of an English-style riding saddle. Stars, targets, flowers, a "seashell" design, and patriotic carvings were all part of the Parker look. Unusual hip and cantle carvings

15

were also common. Spaniels, flowers, ears of corn, crossed leaves, owlish-looking creatures, and many other unidentified animals were often found behind the saddle. The hip carried everything from guns, flags, and dead game to birds on a swing and fish.

6. The horse shoes were made of cast metal. They often had Parker's name and the inscription "11-Worth, Kansas" on the bottom also.

7. Muscles were indicated with simple-gouge marks. The sides of the knees were also dimpled with a gouge, and multiple creases were cut with a V-tool to indicate skin folds where the legs joined the body. Small parallel cuts were placed behind the hocks to form the "feathers."

PLEASE NOTE that the Carving Instructions given in Chapter 7 can be used to carve any of the carousel figures in this book. However, the illustrations shown are specifically for the C. W. Parker Flag Horse.

Look for the features of a Parker horse (as discussed in this chapter) when you are studying these illustrations.

Chapter 7

CARVING STEPS

I have been carving carousel horses and figures for a long time. I know I have carved over 1,000 of them. Eventually, if you keep working at something for a long time, you begin to learn and to devise better ways to do things. I have established some systematic steps that I go through each time I carve a figure. Sometimes, I make small variations to this system because of some particular peculiarity in the figure I am carving. But basically, I carve all of my carousel figures using the same basic steps.

SCALE

The patterns in this book are on a scale of 1 1/2 inches to one foot. The patterns can be reduced or enlarged to any size you want. Remember, however, that the thickness of an actual carousel animal is approximately one foot, so the thickness of the wood you are carving from should be adjusted accordingly to keep it in scale.

If you carve your animals the same size as the patterns in this book, the wood you work with should be 1 1/2 inches thick (the ratio being 1 1/2 inches: 1 foot). I often use 3-inch thick stock and rip it in half, OR —- I cut out the blank from 3-inch wood and then split it to get two identical blanks.

Select your wood in the proper thickness for the scale you want to work in.

Following are detailed step-by-step photographs for carving a carousel horse. These illustrations are all for the C.W. Parker Flag Horse, but the same basic procedure is used to carve any carousel animal. If you start with the

flag horse (which is the simplest figure in this book), and follow along with the illustrations for it, you will find it very easy to carry what you learned from this carving on to the other patterns in this book, and to your own patterns as well.

(Author's Note: The same basic procedures will be used for all the patterns in this book. Special carving hints are given where necessary for the other patterns. Instructions that are specific to the flag horse will appear in brackets as shown ([]).

STEPS FOR CARVING A CAROUSEL HORSE

1. REPRODUCE THE PATTERN. I usually use tracing paper, but you can use a xerox copy if you prefer. Save the original pattern so you can use it over and over again. The tracing paper allows you to modify the pattern in any way you want without changing the original as shown in figure 12, below.

figure 12: Make a tracing paper copy of the carousel book pattern for transfer to the wood using pencil carbon.

2. TRANSFER THE PATTERN TO THE WOOD. I almost always carve from basswood (linden). Line the pattern up on the wood to make the best use of the grain. I try to have the grain running with the weakest part of the carving, which is usually the legs. (There is always one leg that goes in the wrong direction, which will then make it weak, but three out of four is pretty good odds!) The direction of the wood grain should be marked on the pattern.

Using the tracing paper pattern, you can see the grain through the paper to determine the best alignment. I use pencil carbon paper (not typewriter carbon) to trace off the pattern onto the wood.

NOTE: For horses that have a bowed head, take special note of the section below on properly tracing the pattern onto the wood.

3. CUT OUT THE BLANK. As mentioned before, I cut out my blanks on a 12-inch, 2-wheel bandsaw. A blank is the basic shape of the animal cut out from a piece of wood upon which you will then do the carving. On the saw, I use a 3/16-inch, 4 teeth-to-the-inch, skip-tooth bandsaw blade. It turns pretty tight, but it can be pulled off the wheel of the bandsaw if you try to back up. I try not to back up through any tight turns, but if I do, I try to go only very short distances.

You can always leave a sharply-angled piece to be cut off later with short straight cuts, rather than trying to do it all at once. Cut as close to the traced outline of the carving as you can. Anything you don't cut off now will have to be carved off later, as shown in Figure 13 which follows.

[The flag horse pattern can be cut out differently than the other patterns in this book. The entire flag horse silhouette can be cut out

figure 13: Cut out the blank. Cut as close to the outline of the carving as you can.

on the band saw, (as shown in figure 13), and then the head and neck cut at the harness line with a thin razor or veneer saw.]

Most of the other patterns in this book should be traced and cut out in separate pieces of head/neck/body. If the head is bowed so it is close to the legs, it is difficult to carve the details of the nostrils and teeth, and sometimes the front legs themselves, without separating the pattern on the block of wood so the pieces can be cut out separately on the band saw. The separate patterns should be close enough together on the wood so the grain matches and goes in the same direction. The wood has to be very smooth where the pieces will butt together. You should either cut the butt joints very straight or leave a little extra wood so that it can be sanded smooth. Any pieces that are to be laminated to the body block should be cut out of sheet stock scrap that is the appropriate thickness. Be sure the wood grain goes in the same direction as the grain in the body.

See figure 14 on the following page.

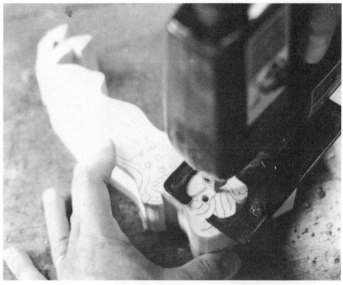

figure 14: The flag horse blank consists of 3 pieces.

figure 16: Drill a starter hole and clean out waste under tail.

4. DRILL STARTER HOLES IN MANE AND UNDER THE TAIL. Drill a small hole (1/8 inch) in the mane where the peek-a-boo hole will be. Also drill a hole under the tail behind the rump as a starter hole to cut out the waste wood there. I use a sabre saw to cut under the tail. Most long-tailed horses have the tail touching one of the rear legs so it cannot be cut out on the bandsaw. See figures 15 and 16 which follow.

5. DRILL THE POLE HOLE. The pole hole should be located directly in front of the saddle, and centered on the width of the body. Measure the width of the body at that point with a ruler, and mark the center for a 1/4-inch diameter hole with the point of an awl. If the horse is a jumper, I make a jig out of a piece of scrap 2 X 4, with a 1 1/2 inch square notch cut in it that will fit on the belly of the horse to keep it vertically squared up as shown in figure 17 below.

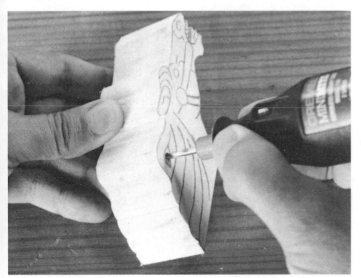

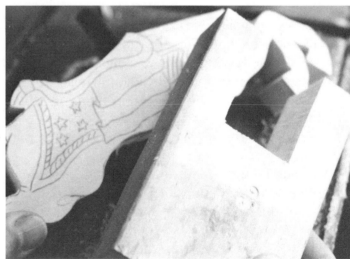

figure 15: Drill guide holes for peek-a-boo holes in the mane

figure 17: Make a drill jig with squared-off sides to hold the horse in the drill press. The space in the notch should be the same as the thickness of the horse.

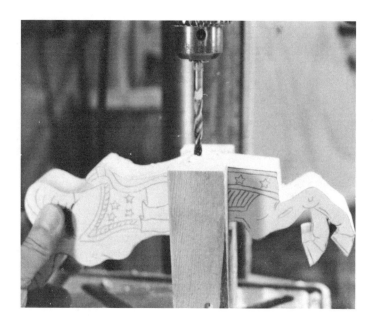

figure 18: Drill 1/4-inch pole hole using the drill jig

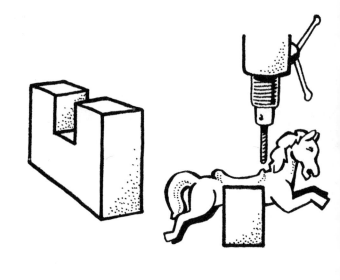

figure 19: The pole hole drilling system for a "jumper."

Placing the horse in the jig keeps pressure off the legs and prevents breaking them while drilling the hole. (**NOTE:** All of the horses in this book are jumpers and should be drilled using a jig, but the legs on a stander are strong enough to take the pressure and would not require the use of the jig.)

I drill my holes with a drill press, using a 1/4 inch twist bit with a brad point. If you put the point of the drill bit in the hole you made with the awl, it will not walk on you and will drill a nice straight hole. The body of the horse should be almost level when the hole is drilled, but sometimes just a little head up. (Imagine that someone is in the saddle you just cut out. If it is tipped back too far, they would slide right over the horse's rump.) See figures 18 and 19, above.

Sometimes I have to use a 1/4-inch extender bit to complete the hole. That always happens when the neck or mane is too close to the hole and won't clear the chuck on the drill. But I still always start the hole on the drill press, because an extended bit tends to be wobbly and wants to wander.

SEPARATE THE LEGS. Using a good black #2 pencil, mark out the legs on the blank. (as shown in figure 20 below.)

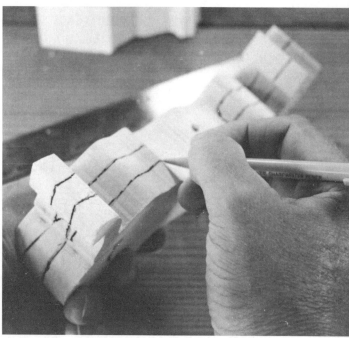

figure 20: Draw legs and tail on the ends, top and bottom of the blank, dividing the blank approximately into thirds.

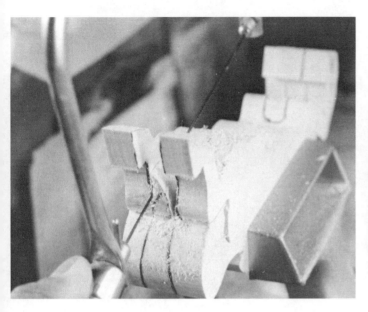

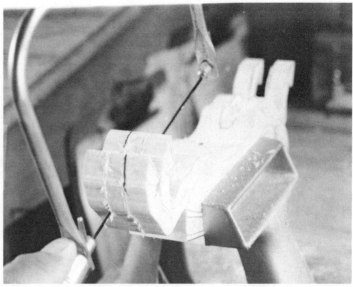

figure 21: Using a coping saw, cut away the waste wood between the rear legs. [CAUTION: The tail is attached to the inside right rear leg.]

figure 22: Separate the front legs with a coping saw. DO NOT CUT INTO THE BODY. When the center piece falls out, you should have four front legs.

Each leg is approximately 1/3 the width of the body. From the front, the legs should be no more than 1/2-inch wide, with a 1/2-inch separation between them. The rear legs are a little thicker where they are attached to the body, but should have a 1/4-inch separation at that point. Then the leg thins rapidly down to less than 1/2-inch. The hoof, near the shoe, is about 1/2-inch wide. The rest of the leg swells over the joints and narrows over the leg bones.

Turn the carving upside down in a wood vise and cut out the separation between the legs with a coping saw. (as shown in figures 21 and 22 above)

(Some carvings may now have eight legs marked out on the blank!) Be sure to select the correct four legs to retain, and cut the others off. (See figure 23 below.)

figure 23: Select the two front legs you want to save, and cut off the other two with the coping saw.

Sometimes this can be done with a coping saw; other times you will need to carve off the excess wood. I use a 1/2-inch gouge to clean up the saw marks between the legs. Then, carve down around the rump between the legs to create a separation between the rump and the front of the tail. (Figure 24 below.)

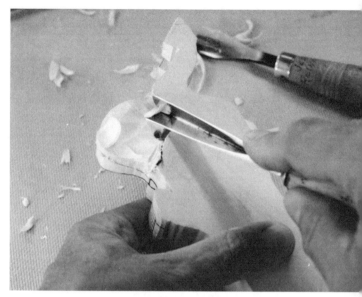

figure 25: Using a V-tool to outline legs and rump.

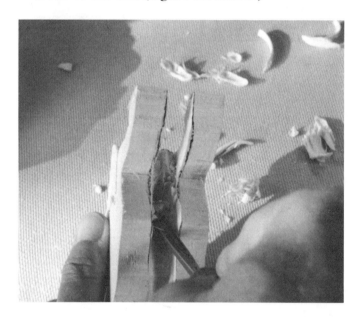

figure 24: Cleaning up and smoothing between the legs. Carve down to create a separation between the front of the tail and the rump.

7. CARVE AWAY THE EXCESS WOOD ON BOTH SIDES OF THE TAIL.. Carve around the back of the rump and above both legs, with deep gouges and V-tools to create a silhouette like the pattern. I like to remove most of the wood with a flat gouge

figure 26; A larger flat gouge can then be used to rapidly remove the unwanted wood on both sides of the tail.

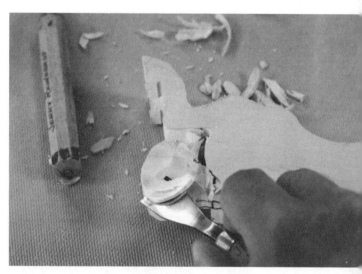

Use a V-tool to outline the legs and rump. Carve deeply. Use a large V-tool. (See figure 24 above, right.)

Carve off the excess wood on both sides of the tail with a flat gouge. (Figures 25 and 26 at right)

figure 27: At this stage, the tail and legs should be rather squarish, but completely blocked out. Notice the separation between the tail and the left leg.

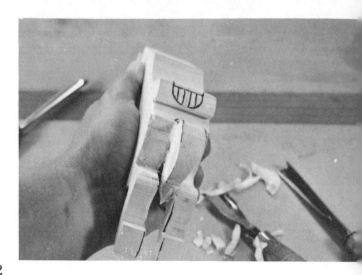

8. *LAMINATE ANY RAISED AREAS OF THE DETAILS.* Rather than carving everything else down from a raised area on the side of the horse, I build up that area by laminating onto the blank (gluing sheet stock to the side of the horse to make it the desired level). [On the Parker flag horse, the "flag" is raised up, and is the only piece laminated on.] The section to be laminated, [in this case, the flag] is cut from sheet stock about 1/8-inch thick. Trace the pattern of the raised area onto a piece of sheet stock that is the appropriate thickness. Be sure to trace the pattern onto the wood so that the grain of the sheet stock will be running in the same direction as the blank it will be glued to. Then cut the silhouette of the add-on piece with a scroll saw or coping saw with very fine teeth. Sand the back side lightly to remove any loose wood and glue it on with a thin coat of yellow wood glue. Clamp it in place for at least 20 minutes. (NOTE: Sheet stock can be easily ripped in various thicknesses, on a bandsaw, from pieces of scrap wood.) See Figure 28 below.

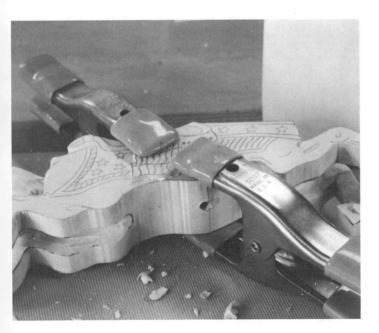

figure 28: While the body blank is still flat, laminate on any raised area [the flag, in this case], using carpenters glue and clamps.

9. *CARVE THE HEAD/NECK (IF SEPARATE FROM THE BODY).* Note: You will find that, in many cases, carousel horse heads must be carved separately from the body. (Sometimes, the neck is also carved separately.) Some of the patterns in this book are like that.

A carousel horse with a bowed head is difficult to carve if it is carved from a one-piece blank, especially because there is usually a leg or knee located less than a quarter of an inch from the teeth and nostrils. So, I do what the original carousel carvers did, and carve the head before it is attached to the rest of the horse. I suggest that you use the same procedure.

[As previously noted, the flag horse's head is not separate from the neck — it is carved from one piece — but the neck is separated from the body at the harness line.]

If you are carving a horse with the head separate, the head should be carved now, before proceeding. Skip ahead and follow the directions and illustrations for "Carving the Head," which can be found on pages xx through xx of this chapter.

With your #2 pencil, draw a centerline from between the ears, across the front of the head, and between the nostrils. Then draw the silhouette of the front of the head on the block, using the centerline to measure from, to make sure each side is equal. The area above the eyes is the widest part of the head. The cheek bones and the width of the nostrils varies from manufacturer to manufacturer. Check each pattern in this book individually for the correct width of each particular horse.

(See the illustration in figure 29, on the following page.)

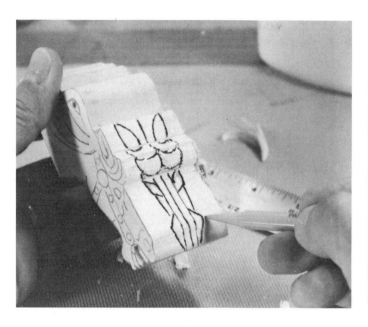

figure 29: Draw the top view of the head. (See Parker Rose pattern). First, draw a centerline, then using the pattern, draw the silhouette of the head, making sure each side of the drawing is an equal distance from the centerline.

Cut out the front silhouette of the head using a coping saw or band saw (as shown in figures 30 and 31, which follow.)

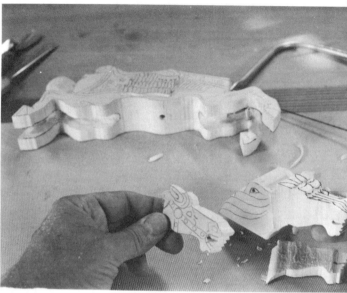

figure 31: This shows the completed cuts of the two pieces from the sides of the head, [plus the flag, now laminated onto the "romance" side of the body.]

Redraw the details on both sides of the head with a soft pencil. (See figure 32, below.)

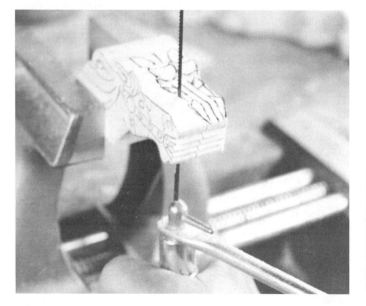

figure30: Clamp the head block into a vise and cut out the head top view silhouette with a coping saw. Cut just past the ears, and then flare out to remove the piece. Leave the neck piece as a block.

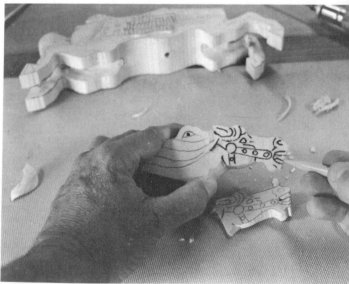

figure 32: Make sure the eyes are placed evenly on the head when drawing the detail back onto the carving.

You may find that it may also be necessary (and easier) to carve the front legs while the head is not attached. If so, do that now also.

10. GLUE THE HEAD TO THE NECK, AND/OR THE NECK TO THE BODY. [The flag horse's head is not separated from the neck.] Most carousel horses have heads that are twisted or looking to the right. (The horses seldom look straight ahead.) It is important that the neck block and the head block be sanded perfectly smooth where they go together. To ensure this smooth finish, I often leave a little extra wood for sanding when I cut the pieces out separately.

Twist the head to the appropriate angle on the neck block. When you are satisfied that it is in the right position, draw a line around the head on the neck block. Then, with a V-tool, carve a tic-tack-toe design (#) on both surfaces where they will be joined (as shown in figure 33 below.)

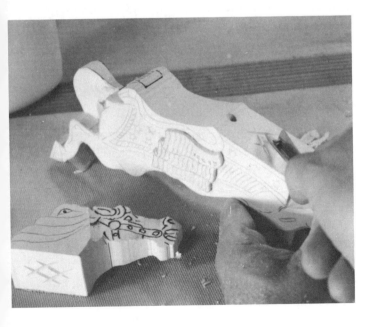

figure 33: Using a V-tool, cut a deep tick-tack-toe (#) design in the center of both the neck and body blocks where they will be glued together. Don't get too close to the outside!

Apply a thin coat of carpenter's glue on the head block, and carefully press it into place on the neck block. Apply pressure to squeeze out any excess glue. Most of the excess glue will squeeze into the tic-tac-toe cuts (#) and when dry, will lock them together permanently. Keep the pressure on for several minutes. Sometimes, strong rubber bands can be used to apply the pressure, but be careful not to let the head slip out of proper position. Using the same technique, glue the neck to be body of the horse. Be sure the front of the neck block is forward so that it is even with the front of the chest. (See Figure 34., below.)

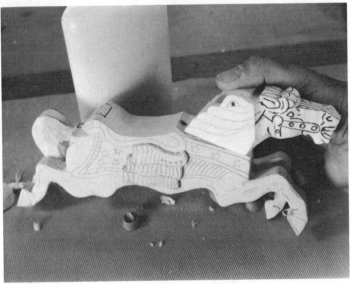

figure 34: Apply glue to cover the bottom of the neck block. Press into place with the chin over the right front leg, and the front of the neck even with the front of the chest.

11. DRAW A CENTER LINE DOWN THE BACK OF THE HORSE. A center line should be drawn from between the ears, down the curve of the neck, through the pole hole, and across the saddle to the center of the tail. Most of this line should remain in place as the high spot on the carving.

Draw in the top view of the object behind the saddle. [In the case of the flag horse, draw in the shield.] (See figure 35 on the following page.)

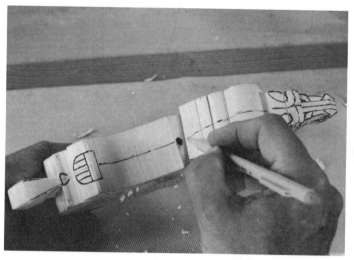

figure 35: Draw a centerline connecting the head to the tail. Also draw the top view of the carving behind the saddle.

12. ROUGH SHAPE THE ENTIRE CAROUSEL HORSE. Primarily using gouges and knives, begin to shape the entire carousel figure so it begins to look like all the parts blend together. I usually start by carving the neck block down, so that it is narrower than the shoulders of the horse. (Caution—-don't use the shoulder trappings as the base of the neck. Usually the shoulder bone extends above those trappings, and the neck slims down from that.) (See figure 36 and 37, which follow.)

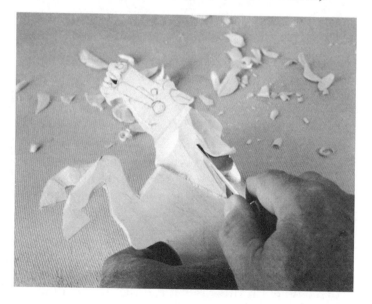

figure 36: Using shallow gouges, and sometimes a knife, begin rough-shaping the body and neck.

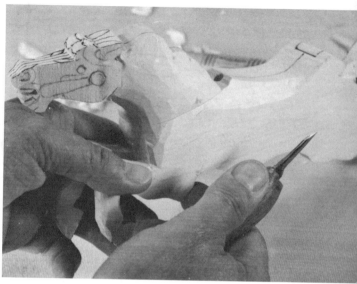

figure 37

Round the chest across the front of the horse. Redraw any of the details you may have just carved off.

Round over the back and belly of the horse. Be careful to reserve enough wood for any details that may stick out, especially behind the saddle or side trappings. If appropriate, carve a shallow vertical depression behind and in front of the rib cage on the sides of the horse, to help give the illusion of three dimensional shape that really isn't there.

Carve the rump by rounding across the back under the tail and across the top. There is usually a shallow separation between the legs all the way up to the base of the tail.

Informational Note: On full-size carousel horses, the tails were always made of either real horse hair or were wooden tails that were carved separately, and inserted into a socket at the end of the back bone. If it was a long wooden tail, the end of the tail was always attached to a rear leg with a wooden dowel, to give it strength and to make sure some child didn't succeed in taking the tail home with him as a souvenir.

26

I usually use a small V-tool and carve a line in the wood to indicate where the tail is inserted into the socket in the rump. The horses in this book also have a narrow, shallow depression that extends up the backbone from the base of the socket to the trappings or back of the saddle. Use a small shallow gouge to form

he depression. The depression separates above the tail socket to form a "Y" shape around the socket, and then blends away down the back of the rump.

Detailed illustrations of the shaping proceudre for roughing out the horse shape follow in figures 38 through 48.

figure 38: The body and neck of the figure should start to look like they belong together

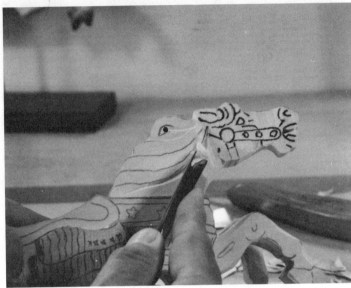

figure 39: With a large V-tool, begin to undercut the outline of the mane on the romance side of the horse.

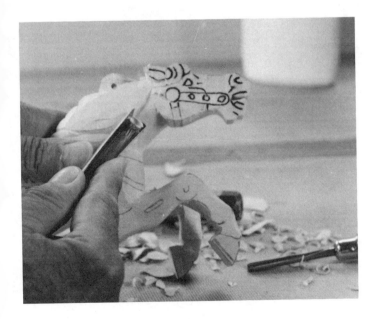

figure 40: Blend the neck into the head and shoulders, leaving the block of wood for the mane above it.

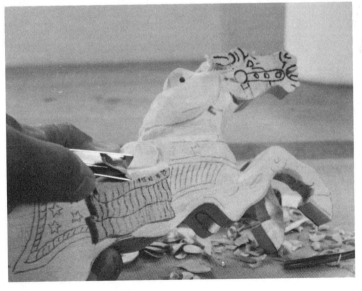

figure 41: Using a V-tool laid on its side, carve the top of the flag down, by outlining the bottom of the saddle.

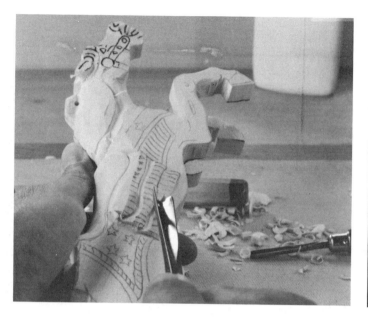

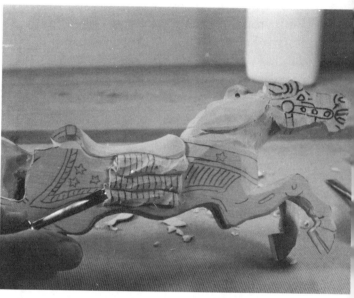

figure 42: Using a V-tool in the same way (laid on its side), carve the two deep folds in the flag.

figure 43: Angled, irregular wrinkles in the flag are then carved across the flag with shallow gouge cuts. (Use different gouges to deepen some cuts and widen others.

Illustrations for Rough-Shaping the Carousel Horse

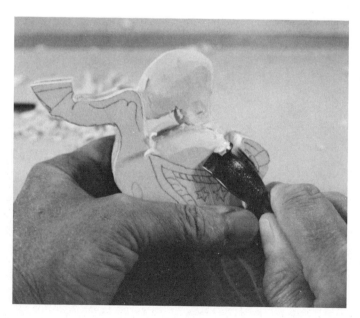

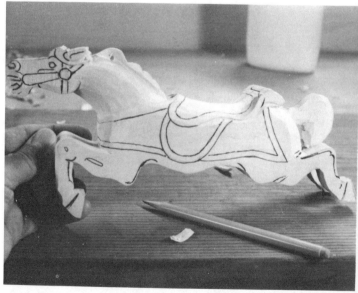

figure 44: Round the rump over, by using a large shallow gouge, held upside down in the reverse position.

figure 45: Draw the details on the reverse side of the figure, using the pattern for reference.

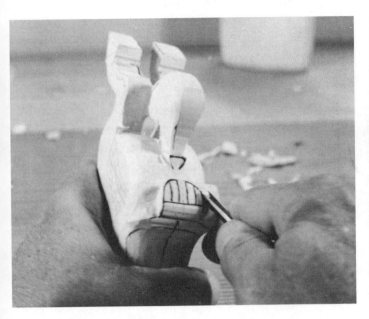

figure 46: Begin shaping the shield behind the saddle by cutting a top silhouette using a larger V-tool.

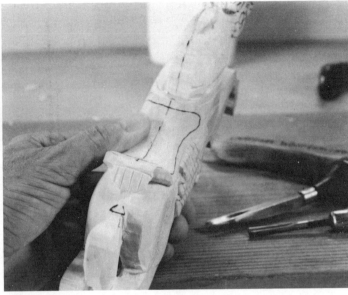

figure 47: Continue shaping the shield by rounding the top over and trace the detail lines of the field and stripes by making shallow cuts with a small V-tool.

13. SHAPE THE LEGS. First, using a gouge, I mark the depressions that are around all of the joints in all of the legs. The deepest cuts are usually around the hocks, above the hoofs. The knee joint is not as pronounced. (See figure 48.)

Then I usually use a knife to shape and round the legs and hoofs (as shown in Figure 49, below.) The tendons that stand out on the back of each of the legs are shaped with a shallow gouge.

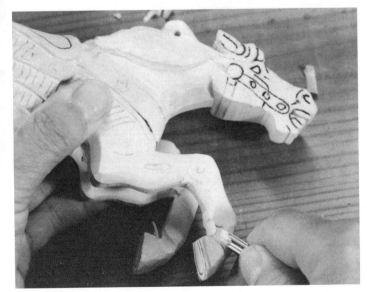

figure 48: Gouge a shallow depression to separate the hock from the hoof.

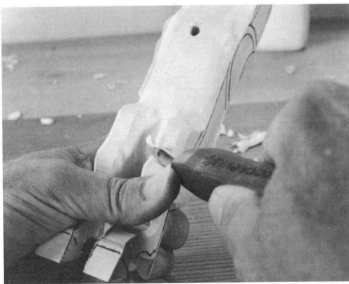

figure 49: Round the bottom of the belly over, and round and blend the legs into the body.

Draw the bottom of the hoof on each of the four legs, and carve the hoof to match the horseshoe shape. The "frog" on the underside and back of the hoof is carved with a small V-tool, after carving the inside of the horse shoe with the same tool.(See figure 50)

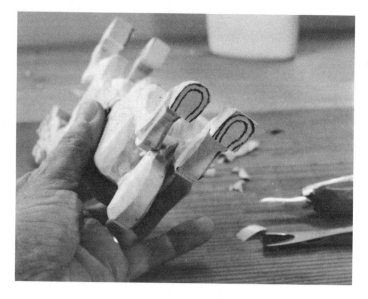

figure 50: Shape the hoof and carve the details of the bottom of the hoof. Try to get all four hooves the same size.

Finish shaping the outside of the hoof, making the top slightly smaller than the bottom. Where the leg joins the hoof, the leg is slightly larger than the hoof, crating a small bulge all around the top of the hoof. (See figure 51.)

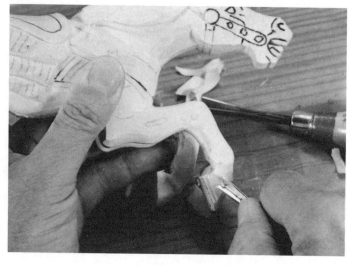

figure 51: Undercut the hock with a V-tool, and carve the top of the hoof down so it is slightly smaller than the hock.

14. CARVE THE HEAD. [The flag horse head can be carved with the neck glued to the body because the head is up and easily accessible.]

I usually start carving the head by working on the mouth and teeth. The front two teeth on the upper and lower jaw are squared to the front of the horse. The next tooth on each side of the front teeth is at a 45 degree angle, and the other teeth are parallel with the sides of the head. Make the teeth BIG, about 1/8-inch wide, as shown in figure 52 (See pattern.)

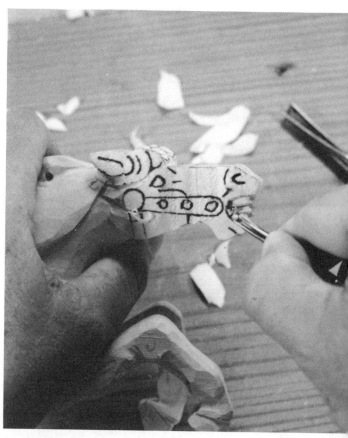

figure 52: Using a small, sharp V-tool, cut and shape the teeth and tongue.

The Parker nostrils [including the nostrils on the flag horse] are formed by making a simple scoop out with a gouge. But note that the outside of the nostrils flare almost as wide as the eyes, when viewed from the front of the head. (See figures 52 and 53 on next page.)

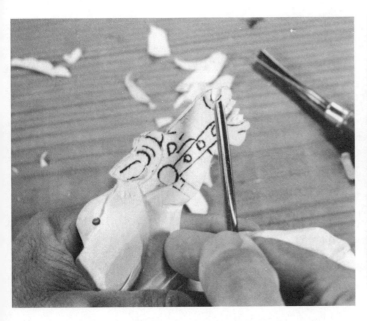

figure 53: A small "veiner," or a small deep gouge should be used to cut the depression on the inside of the horse's nostrils.

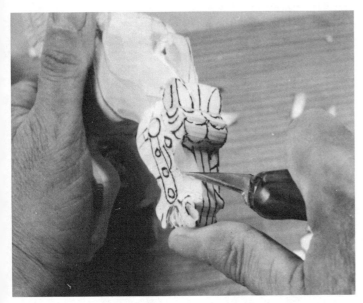

figure 54: Narrow the ridge of the nose between the nostrils and eyes to 1/4-inch down the ridge. It should remain wider near the bridle. Shape the muzzle so that the nostrils flare almost as wide as the eyes.

Shape the chin so it is cup-shaped (like half of a ball). Use a small gouge and under-cut the lips so they remain prominent (as shown in figure 55, above right).

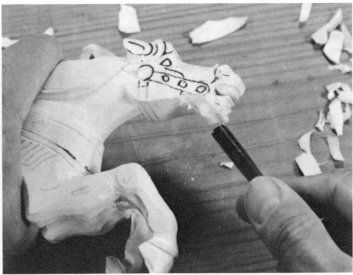

figure 55: A Parker has a half ball-shaped chin. Shape it with a shallow gouge.

The forelock is divided in the middle of the head (on a Parker) and wraps around both ears, back to the mane. Carve the base of the outside of the ears down so that it looks like the mane is around the ears.(See figure 56 below.)

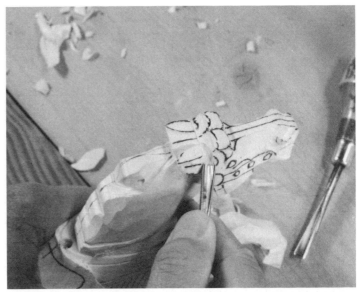

figure 56: Cut around each ear with a V-tool. Undercut the ear to make the bottom of the forelock look like it goes under the ear. Undercut the forelock on the top front so it appears the ear goes under the forelock.

Carve the ears so that they are cone-shaped and rounded. There is a shallow depression, indicating the inside of the ear, on the outside of each ear. (See figures 57 and 58, which follow.)

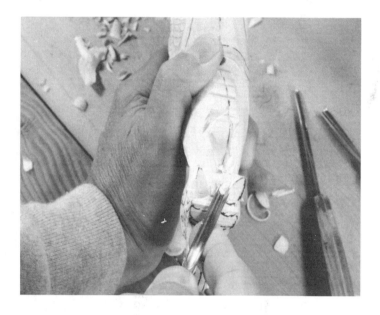

figure 57: The ears are cone-shaped, with a shallow depression on the outside. Clean out the excess wood between the ears with a gouge to make the forelock flow into the mane.

When carving the head of any carousel horse, be sure to carve away the wood to the front of the eyes so that the horse can look forward, but keep the eyeballs at the widest part of the head. (Imagine that the horse is looking with both eyes straight ahead. When you look at your carving from the front, you should be able to see both eyes.)

I like to use my eyeball tool to make the eyes. It insures that they will both be the same size.

[Most Parkers, including our flag horse, have an inverted "V" carved in over each eye, that perhaps is intended to resemble an eyelid.]

See figures 59 through 64, which follow, showing the process of carving the eye. Check back to figure 10 for detailed illustrations on carving the eyeball itself.

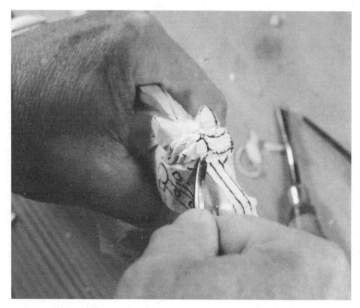

figure 58: Undercut and shape the forelock on the forehead with a small V-tool. Carve major separations of hanks of hair, so they roll and swirl back between the ears.

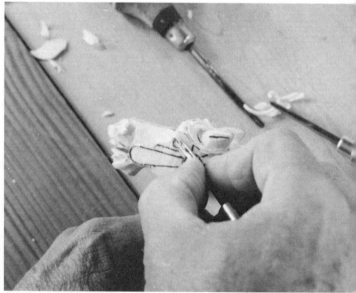

figure 59: Use a small sharp V-tool and cut around the outline of each eyeball. (See Figure 9.)

There is a heavy cheekbone under the eye, going forward about half the length of the head and curving down and around to the neck. The back of the cheekbone comes up and points at the base of the ear. The area of the muzzle between the cheekbone and the nostrils is the narrowest part of the head. See figure 63, below.

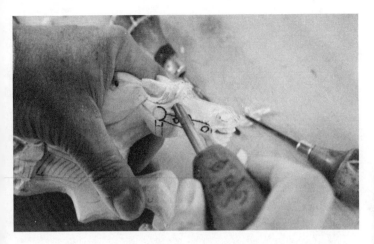

figure 60: If you made an eyeball tool, use it now. Place it over the eye in the V-tool cuts, apply pressure and twist back and forth. Repeat until the eyeball is round and burnished.

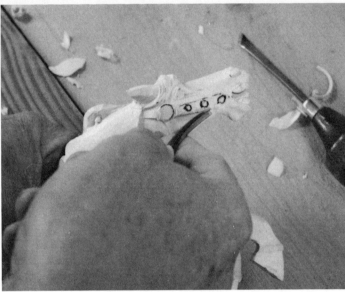

figure 63: Outline the bridle with a small V-tool by cutting on the "horse" side of the bridle to give the bridle a slightly elevated look.

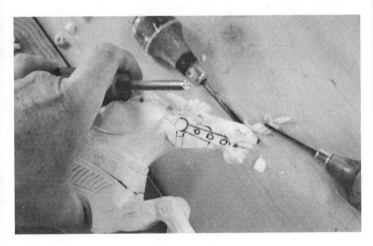

figure 61: The eyeball tool and a round, burnished eye.

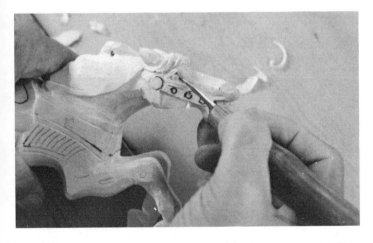

figure 62: Using a small, sharp pointed knife, cut out a small triangle in the two corners of each eye. Then re-burnish with the eyeball tool.

15. CARVE THE MANE AND TAIL. The mane and tail are often the most interesting part of the carving, the thing that catches the eye and makes someone take a second admiring look. [Parker manes were generally rather simple compared to those of other manufacturers. But still, they were carved deeply in a style easily recognizable as Parker's. Parker horses often had "Peek-a-boo" holes visible through their swirling manes. The mane usually consisted of large hanks or blobs of hair, pulled in overlapping swirls down and across the back of the neck. They parted around the holes in the mane, and dipped under each other to form a "pulled taffy" look. The tails had the same look.]

Your V-tools and small gouges are the best tools to use when working on manes and tails. as shown below in figures 64, 65, 66, and 67).

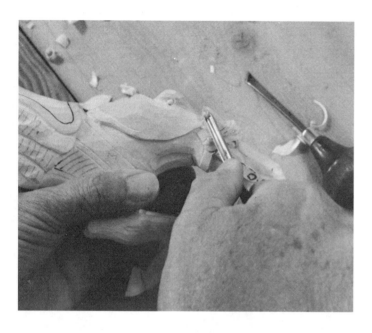

figure 64: Hollow a depression on the outside of each ear with a small gouge or "veiner."

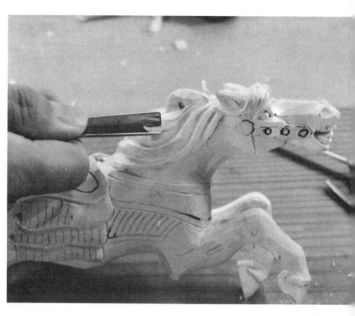

figure 65: Shape major swirls in the mane with a large V-tool. Make the cuts irregular, and have some pieces of mane fold underneath others.(Note the starter hole for the peek-a-boo to the right of the V-tool.)

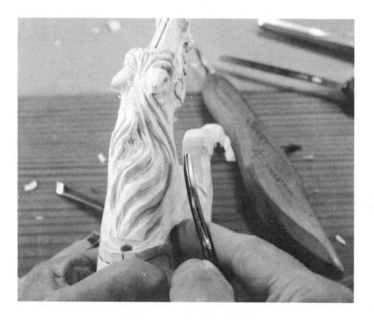

figure 66: Clean up, widen, and deepen some cuts with a smaller V-tool. Notice the way the mane swirls across the back of the neck.

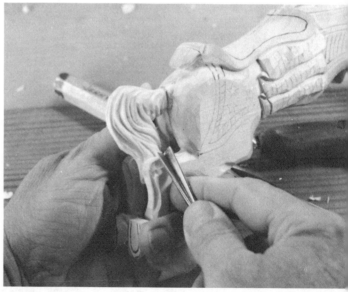

figure 67: Use the same technique on the tail as was used on the mane to create a swirling effect.

16. *MAKE THE TRAPPINGS LOOK THREE-DIMENSIONAL.* To create the illusion of depth in your carving, where there really is very little, you must utilize some skill as well as some deception.

First, decide in your own mind how many levels of trappings there will be on the figure you are carving. Generally, the first level above the hide of the animal is the saddle blanket. Next comes the saddle girth, or sometimes the saddle skirt. The saddle seat usually overlaps everything else. Often, there is some special ornamentation that is above all of the other trappings.

I carve the very top layer of trappings first. If you outline that outside layer with a V-tool, cut down about 1/16 of an inch. Each subsequent layer should step down another 1/16-inch also. Make these cuts by taking a small sharp V-tool and laying it on its side so that one ear of the V-tool is almost vertical. Then, by cutting on the side of the line where you want to lower the wood, you will create a separation with a shallow trench on one side and a sharp elevation on the other.

With a sharp knife or a skew, blend out the outside of the cut so that you don't see the original cut made by the lower ear of the V-tool. Try to cut with the grain on the wood as much as possible while you are doing this. Repeat the process for each level of trappings. Create as much depth in your carving as possible. Check to make sure that everything that is supposed to be under something else looks like it is below it in depth. (See figures 68 and 69, which follow on the right.)

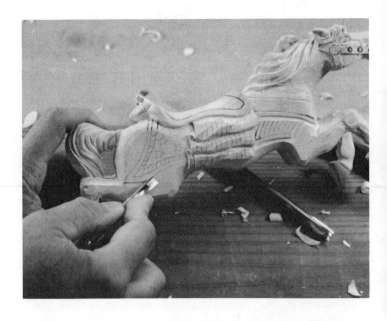

figure 68: Outline and undercut the edge of all the different layers of trappings with a V-tool laying on its side. Always cut wood away on the "horse" side of the line.

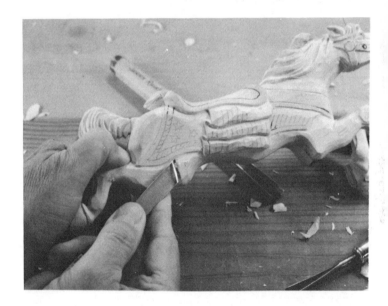

figure 69: Use a skew to flatten or shave out the sharp trench made by the V-tool. Gradually work the top surface of the lower surface away until you see no depression. Do this around all levels of the trappings.

[***Carving Hint:*** The flag on the flag horse tucks underneath the seat of the saddle much like a saddle blanket normally would. The flag has two fold-over lines that must be cut in first with a V-tool. It also has some shallow wrinkles angling across it, which can be carved with a simple gouge next. Then cut very small separations with a small V-tool to indicate the stripes. Remember, you have to have 13 stripes and six of them are below the field of stars. I do not attempt to carve stars on the flag; it is just too small. Just paint them on later.]

17. *FINAL DETAILS AND CLEAN-UP.*

Now is the time to put in all those small things that finish a carving off. Carve the horse shoes and the "frog" on the bottom of each hoof. Carve tendons on the backs of all the legs that attach to each of the joints of the legs. Gouge out the individual muscles on the legs, rump, shoulders, and chest. Put jewels and other decorations on the trappings, using any jewel maker that you have. (I generally do not like to make jewels smaller than 3/32 of an inch. They become too difficult to paint.)

Clean up the carving with a SAND-O-FLEX. It will remove microscopic pieces of loose wood chips, remove all of the grime and dirt from your hands off the surface of the wood — and turn your carving white again. I usually use a sanding filler with 120 grit split finger sanders.

The SAND-O-FLEX is a great finish sander. But you should be careful with it. I mount mine in an electric hand drill with a variable speed trigger. I like to control the speed as I work it over the carving. It will take out tool marks, sand down into deep cuts, and slick up a flat surface. *But it will also remove detail!*

If you operate it too fast, or with the sanding fingers too long, it can grab delicate parts and break them off. So, be careful. Keep the sander fingers trimmed to only slightly longer than the brushes and operate the sander in a controlled speed.

Check your carving over and re-carve any area that needs it. You are now ready to paint, stain, and/or seal your carving.

ILLUSTRATIONS FOR COMPLETING THE FINAL CARVING DETAILS AND CLEAN-UP PROCEDURES
(Figures 70 - 79)

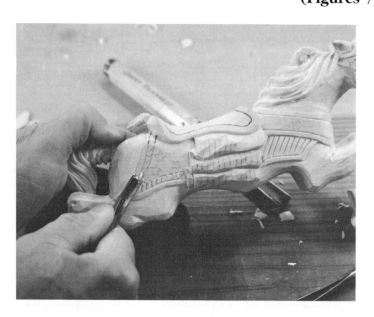
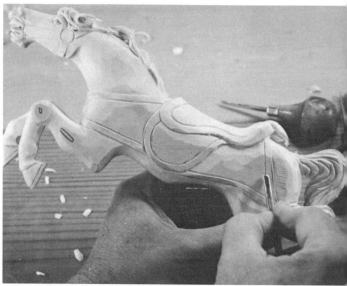

figures 70 and 71: Using a small sharp V-tool, begin making cuts on all of the decorative lines of the trappings. These should be shallow cuts, using the V-tool in an upright position to make a "V" cut. They should be just deep enough to act as a painting guide and for the antiquing to get caught in. Carefully go over the entire carving. If you don't want to attempt to carve the stars on the shoulder harness and blanket, you can use a "jewel maker," and substitute jewels for stars. (See figure 76 for detail of the "star stamp."

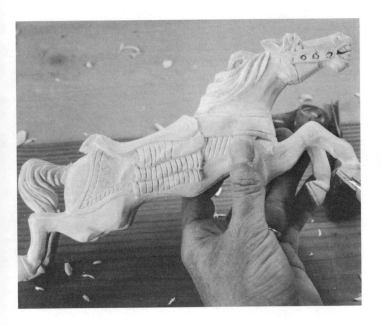

figure 72: Using a small V-tool, carve the separation between the hoof and the horse show on all four feet.

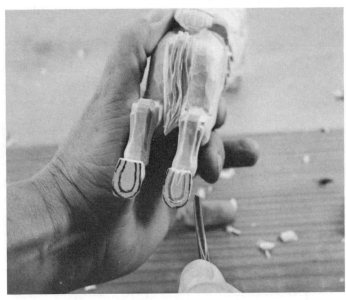

figure 73: Carve out the inside bottom of the hoof, to show the horseshoe and carve the small V-shaped separation between the hoof and the horseshoe on all four feet.

Illustrations for completing the final carving details and clean-up procedures.

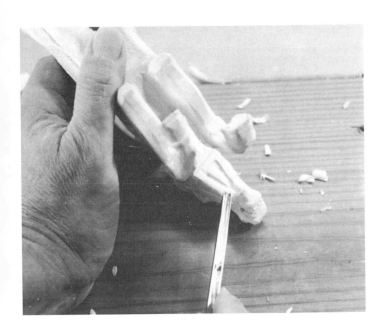

figure 74: Using a shallow gouge, carve a shallow V-shaped depression under the head, behind the chin. This outlines the jawbone of the horse.

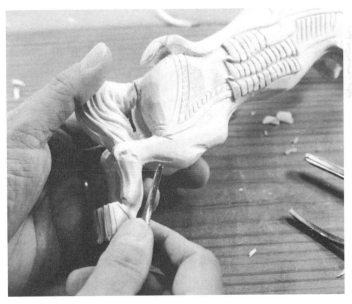

figure 75: Muscles and tendons are carved as depressions on a Parker. Use a veiner or deep small gouge on the legs and joints to carve these depressions.

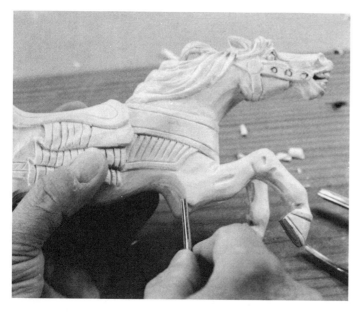

figure 76: Adding the muscle detail. It may be helpful to use the pattern as a guide when making the depressions for muscles and tendons.

figure 77: Leather-working tools, available at shops that sell leather-working materials, can sometimes be used to create certain details. A small star shape was used to punch in the stars.

Illustrations for completing the final carving details and clean-up procedures

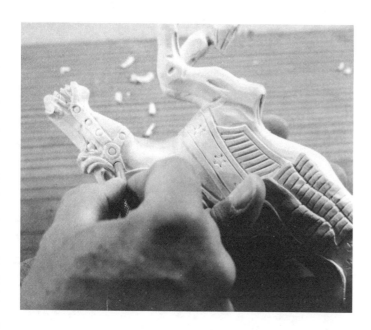

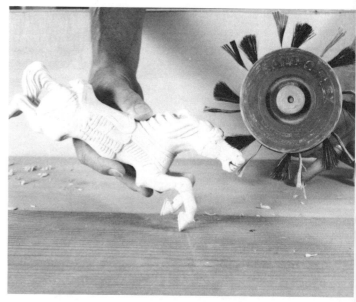

figure 78: Use a "jewel maker" (3/32-inch nail set) to make the jewels. Press and twist it, to create the jewels on the side of the bridle.

figure 79: The carving should be finished. Check it over for mistakes or incomplete cuts. Then use a SAND-O-FLEX with 120 grit sanding fingers to slick up and clean the dirt off your carving.

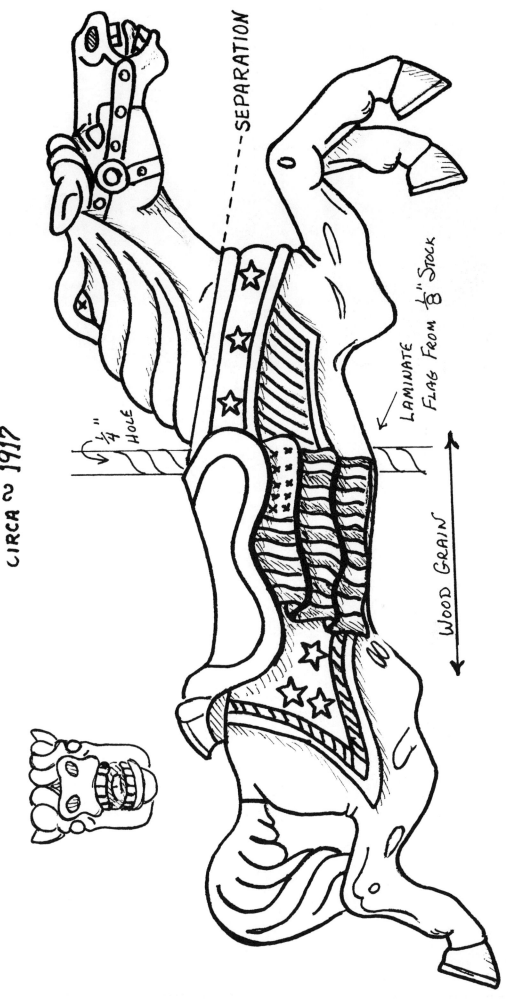

C. W. PARKER FLAG HORSE
LL-WORTH, KS
CIRCA ~ 1917

SEPARATION

½" HOLE

LAMINATE FLAG FROM ⅝" STOCK

WOOD GRAIN

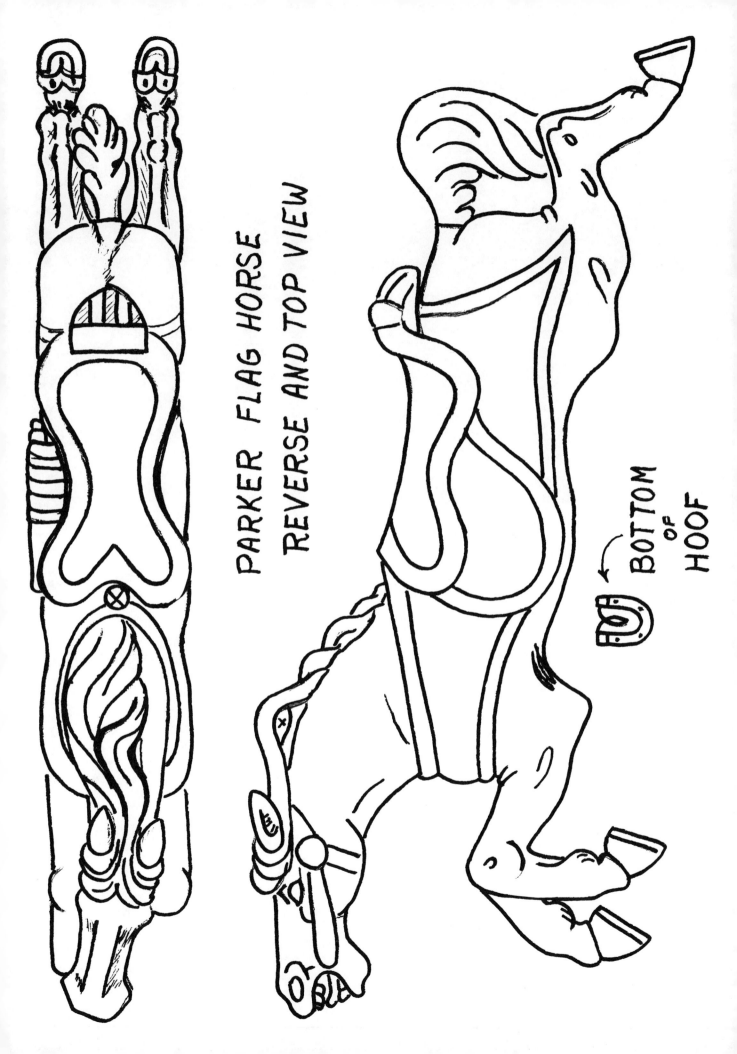

PARKER FLAG HORSE
REVERSE AND TOP VIEW

BOTTOM
OF
HOOF

ALTERNATE TRAPPING DESIGNS
FOR USE ON THE C.W. PARKER FLAG HORSE SILHOUETTE

The long stretch pattern silhouette used to carve the C.W. Parker flag horse can be seen over and over again on a Parker carousel. While the silhouette is the same, many different trapping designs were used to give variety and the appearance of many different horses.

In the Parker factory, the same body block would be used with different head positions, which also increased the illusion of many different designs. The "star gazer" head position was used frequently and was often seen on both the flag horse and the Indian pony designs.

Leg positions were changed less frequently. There were some modifications, but they stayed basically in a "stretch" position. Remember, they still had to fit on the racks in the wagons or trucks used for transporting the carousel. Legs hanging down tended to get caught on things and be more easily broken.

You can easily carve a wide variety of Parker horses using the alternate trapping patterns included in this book.

VARYING YOUR PARKER HORSES

Trace a pattern silhouette of the flag horse, then trace an alternate pattern in place of the flag design. Or, after you cut out the silhouette of the flag horse, trace the different trapping patterns you select onto the side of the horse in place of the flag design. The saddle shape should remain the same, so use that as a guide in lining up the new pattern. Cut out and laminate on any raised areas noted on the pattern, and start carving, using the same procedures outlined in *How to Carve a Carousel Horse*.

CAUTION —- Be sure the wood behind the saddle is sufficient for the cantle carving of the new design. All of the shapes of the cantle designs should fit in the same sized block of wood as the shield, but you can't undercut the block as you would to cut out the shield design.

All of the reverse patterns on Parker horse are pretty standard, and similar to the reverse pattern on the flag horse. *The Indian Pony is an exception!* The animal skin on the Indian pony drapes basically the same on the reverse side as it does on the romance side. The feathers shown on the neck and shoulder are on the romance side *only.*

(Alternate patterns for the C.W. Parker Flag Horse follow)

BLANKET ROLL

(LAMINATE PISTOL & ROPE)

COWBOY
PONY

TOP

FISH

REAR

(LAMINATE FLOWER DESIGN)

CIRCUS
HORSE

TOP

REAR

(LAMINATE RIFLE)

HUNTER'S
PRIDE

TOP

REAR

ROSE
PARADE

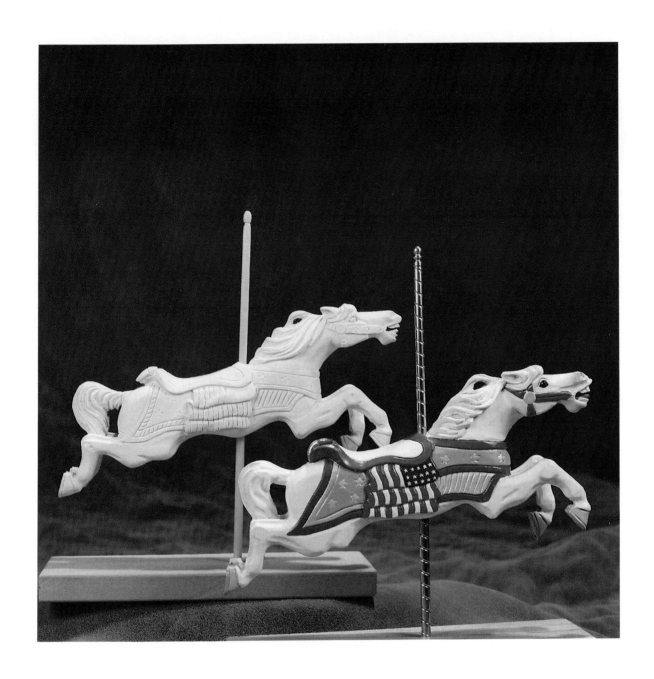

Finished and unfinished views of the C.W. Parker Flag Horse

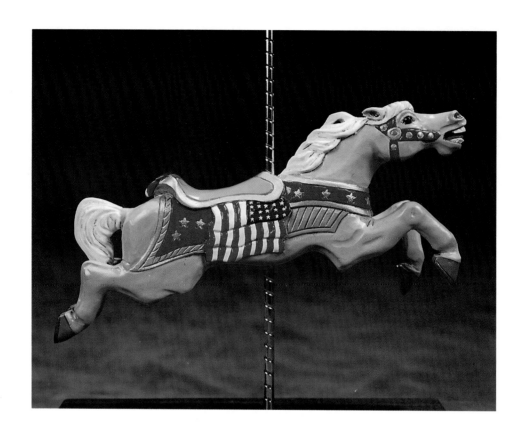

Front and back views of the C.W. Parker Flag Horse

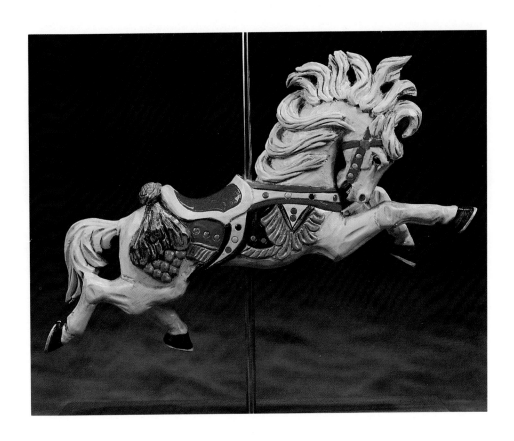

Front and back views of the C. W. Parker "Lillie Belle"

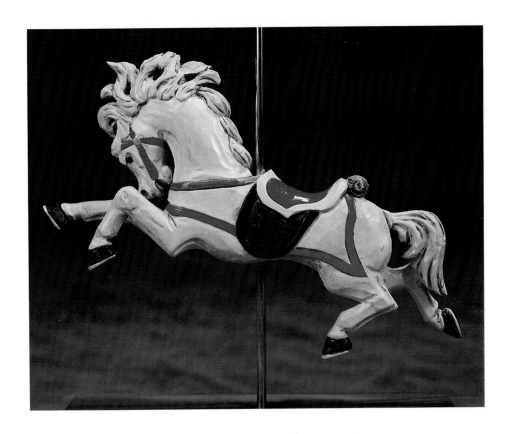

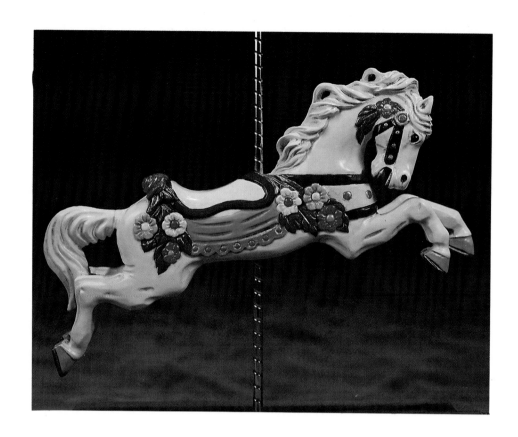

Front and back views of the C. W. Parker American Beauty Rose

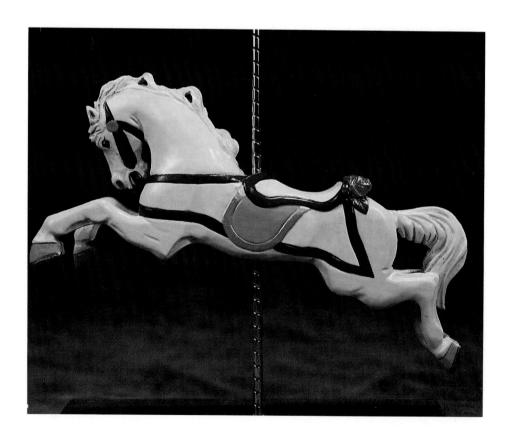

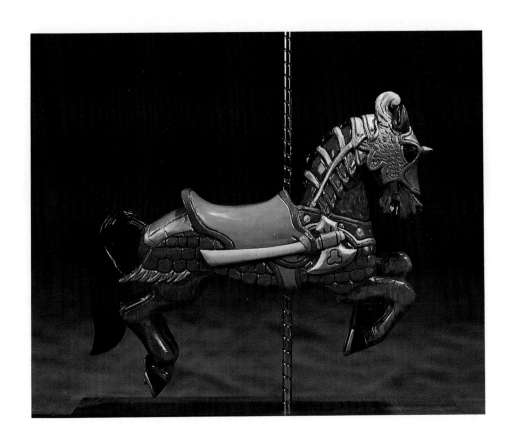

Front and back views of the Spillman Armored Jumper

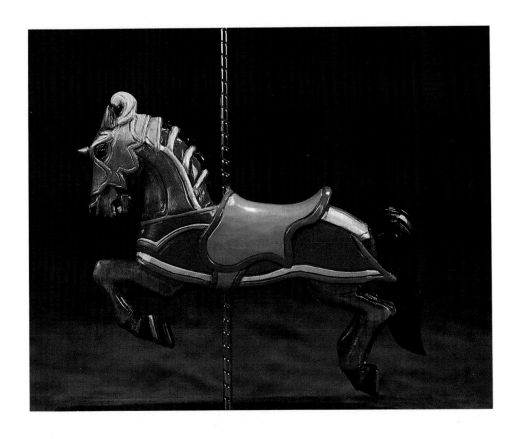

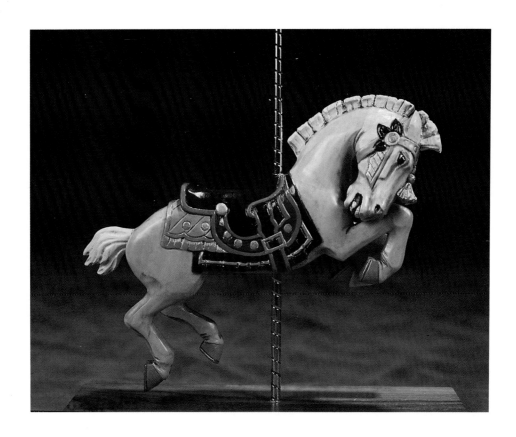

Front and back views of the Allan Herschell Trojan Jumper

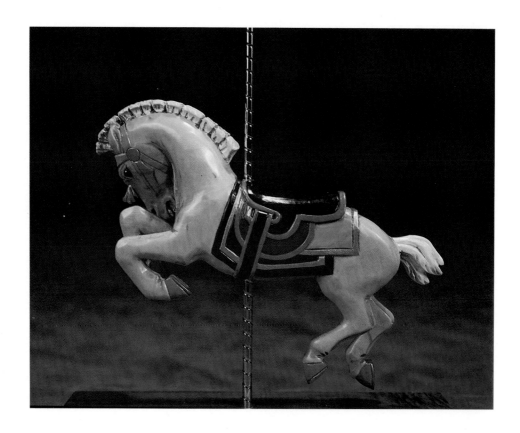

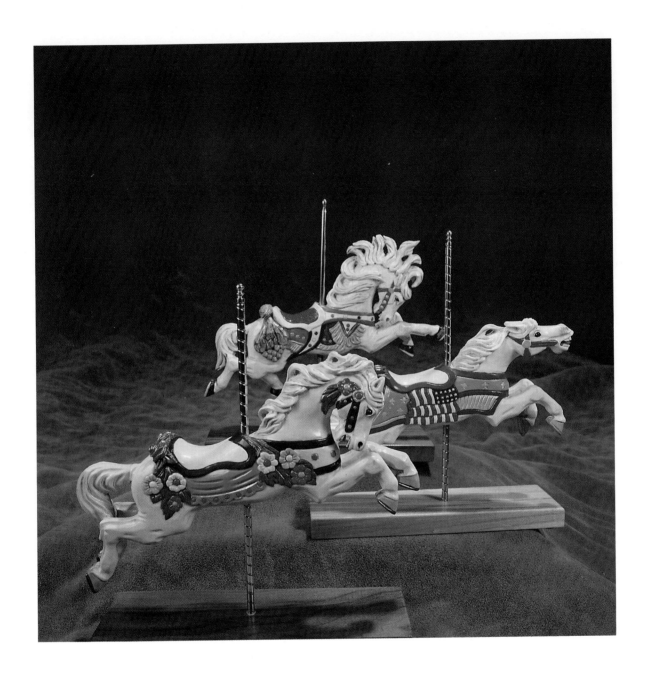

Romance-side views of (front to back) the American Beauty Rose, the Flag Horse, and the "Lillie Belle"

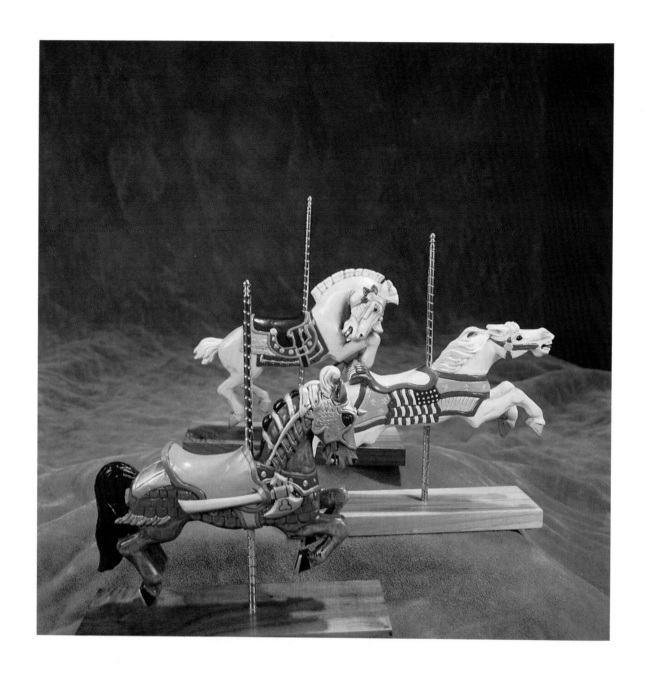

Romance-side views of (front to back) the Trojan Jumper, the Flag Horse, and the Armored Jumper.

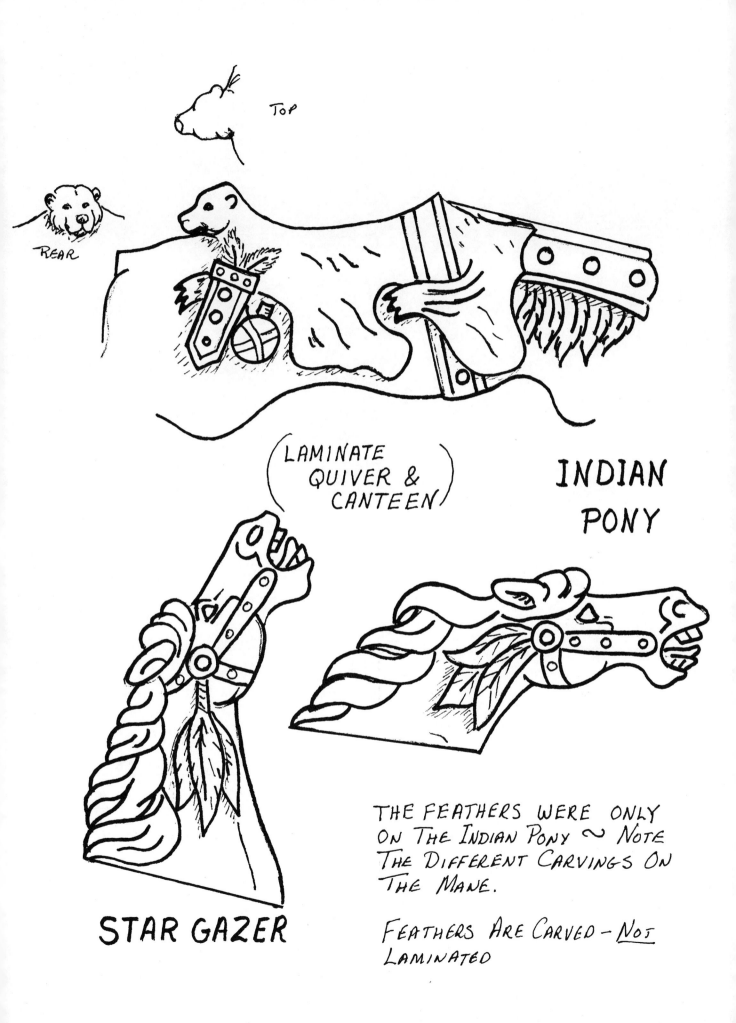

TOP

REAR

(LAMINATE QUIVER & CANTEEN)

INDIAN PONY

STAR GAZER

THE FEATHERS WERE ONLY ON THE INDIAN PONY ~ NOTE THE DIFFERENT CARVINGS ON THE MANE.

FEATHERS ARE CARVED – NOT LAMINATED

Chapter 8

C.W. PARKER CAROUSEL HORSES REVISITED
1914 – 1925

Parker carousel horses went through three different basic variations before they began to look like the horses you see in this book. Initially, they were virtual copies of the Armitage/Herschell horses. Only the trappings were different. Parker saddles were more of a wrap-around-the-back type with a chest strap all the way across the front of the animal.

The second phase of horses had wide open mouths, rear legs stretched back, and front legs raised, but folded back. The horses began to have a long stretched body look. The neck was usually up, but the head was bowed.

The third variation of horses are the ones you see illustrated here. It is the classic "look" for which Parkers became best known. Parkers of this era had a very stretched out look; they had long bodies with relatively short legs which stretched out in front and back. The heads were long, with wide, flaring nostrils. The nostrils were almost as wide as the head was across the eyes and were simple, elongated scoops without detailing.

Parker horse eyes were glass, sometimes with white corners. An upside-down V was very prominant over each eye (possibly to indicate an eyelid). The ears were always laid back and cone-shaped, with a simple gouge mark on one side to indicate the ear opening. The tongue was often curled up and was easily visible.

The mane and tail were carved to look like pulled, twisted taffy; they had a swirled look. The manes often had "peek-a-boo" holes cut through them. The forelock was almost always parted right in the middle with a strand of hair pulled back under the ears on both sides.

The saddles on these horses were long and flat, and almost always had no cinch. The cantle carvings were always unique. Many of Parker's horses had an ear of corn behind their saddle cantles. Parker was the only manufacturer to use corn as a major decoration behind the saddle. (This was probably because of his Kansas heritage.) Leaves, flowers, dog heads, saddle rolls, birds, shields, unidentifiable animals, owl-like creatures, and Billikens (small creatures with big feet and small bodies) all appeared on various Parker cantles. Many times, one can not be sure what an animal carving is supposed to represent. The origins of these carvings were often strictly the creation of the indvidual carvers.

The muscles were indicated with simple gouge marks. The hoofs were rounded with cast-metal horseshoes. Parker's name and "Leavenworth, Kansas" were cast into the bottom of the shoe. Sometimes, a shortened version reading "11-WORTH, KANS." appeared in lieu of the longer imprint. "Feathers" were a series of three cuts on the back of each of the hocks.

Chapter 9

C. W. PARKER'S "LILLIE BELLE" (LEAD HORSE)

The "lead horse" on a Parker carousel after about 1914 was some variation of a pattern known as "Lillie Belle." The story goes that this horse was first designed for Belle Traveling Shows. They wanted a spectacular figure for their new carousel. It is also rumored that Parker was quite impressed with Mr. Belle's wife, Lillie, and he named the new horse after her. Whether this is true or not, "Lillie Belle" was listed in Parker's catalog from then on. Lillie Belle was also called the "King Horse," and was mounted on the carousel opposite from the "Rose" ("Queen") horse. On the larger carousels Parker produced, Lillie Belle had three strands of mane on the side of the neck of the outside row horse. The smaller carousels had only two strands of mane on the neck of the outside row horse. All "Lillie Belles" on an inside row position had only two strands of mane as well.

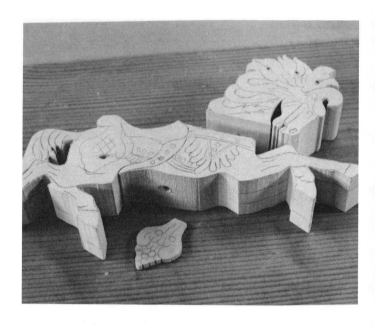

figure 80: "Lille Belle" blank. Note that it is started from 3 pieces. Be sure the wood grain is the same for all three..

CARVING HINTS

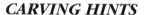

1. "Lillie Belle" should be cut out and assembled from three pieces: head and neck, body, and grapes. The bunch of grapes should be cut from sheet stock about 3/16-inch thick. The grain of the wood of the grapes should be set up so that when they are glued into place, the grain will flow in the same direction as the body of the horse. This will make it much easier to work the carving later on. See figure 80, above right.

2. Glue the grapes into place with a thin coat of wood glue and clamp them into place while the body is still flat and squarish.

3. Drill small pilot holes in the mane about 1/8-inch in diameter, to create the "peek-a-boos." These can be shaped and enlarged later when you carve the mane.

4. Clamp the head into a vise and, with a coping saw, cut off both sides of the head to form a wedge shape. Cut on the outside of the head silhouette. Be sure not to cut into the base of the neck.

(See Figure 81 on the following page.)

5. Carve the teeth, lips, chin, and nostrils and add the bridle details while the head is still

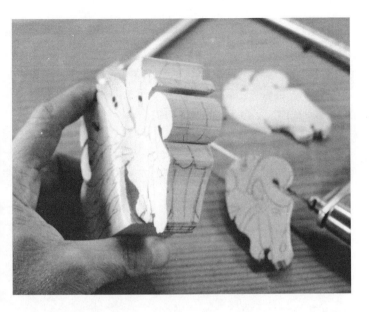

figure 81: Narrow the head block into a wedge shape. A coping saw can be used to cut waste wood from both sides of the head. Re-draw the details on the sides of the head.

separate from the body. Also carve the front legs before gluing the head on. Check to make sure the lips of the horse will clear the right knee of "Lillie Belle," before you glue the head in place. See figure 82, below.

figure 82: Carve the front legs and the head details while the head is still detached.

6. Glue the head and neck to the body after making the # design on both surfaces (as discussed earlier). The right nostril of "Lillie Belle" should be located over the right side of the right knee. The front of the neck should come to the front of the chest harness. After the glue dries, carve just above the chest harness to reduce the neck slightly.

7. "Lillie Belle" has three skeins of mane on the right side of the neck. Carve in between them, 3/16-inch deep to the surface of the neck. Round the neck over to the front. The top part of the mane behind the head is known as a "flame mane," and is over the centerline of the neck, but beginning a little farther down on the right side of the neck, and only slightly left of center on the left side. Enlarge the starter holes of the "peek-a-boos" to fit within the flow of the mane as you carve it. Carve the mane with V-tools and small gouges. The hanks of hair of the mane twist and dip behind each other to give a tangled look. Avoid carving the mane so that all the lines are parallel and it looks like a plowed field. The final appearance should be one with much less structure.

8. Carve the grapes on the hip by first outlining each grape with a small V-tool. With a sharp pointed knife, cut out a small triangle between each grape. Then shape each grape. I use a burnishing tool (about 7/32 inches) slightly larger than my eyeball tool. It forms perfect grapes every time and can sometimes be used for jewels too. (See the section on making an eyeball tool for more details.)

9. As mentioned, many of Parker's horses had an ear of corn carved behind their saddle cantles. Parker was the only carousel manufacturer that used corn as a major decoration behind the saddle (probably because of his Kansas heritage.) Shape the ear of corn first. The husk is partially pulled back, to show the kernels of corn. With a small V- tool, carve across the grain of the wood first (across the

horse), creating the rows of corn. Then, with the same tool, cut in the other direction to create the individual kernels. (The kernels won't split out if you cut them in this order.)

ILLUSTRATIONS FOR THE C.W. PARKER *"LILLIE BELLE"*

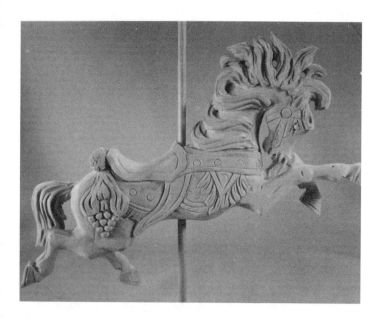

figure 83

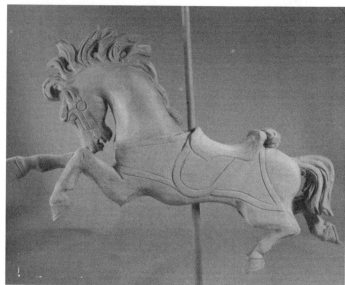

figure 84

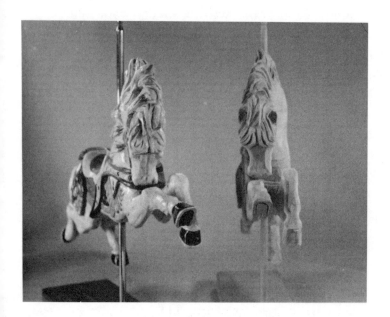

figure 85

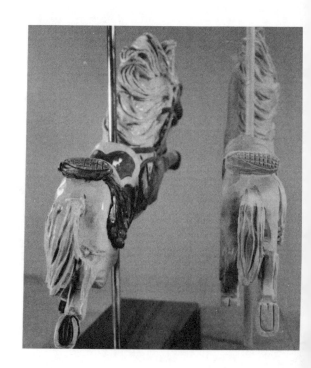

figure 86

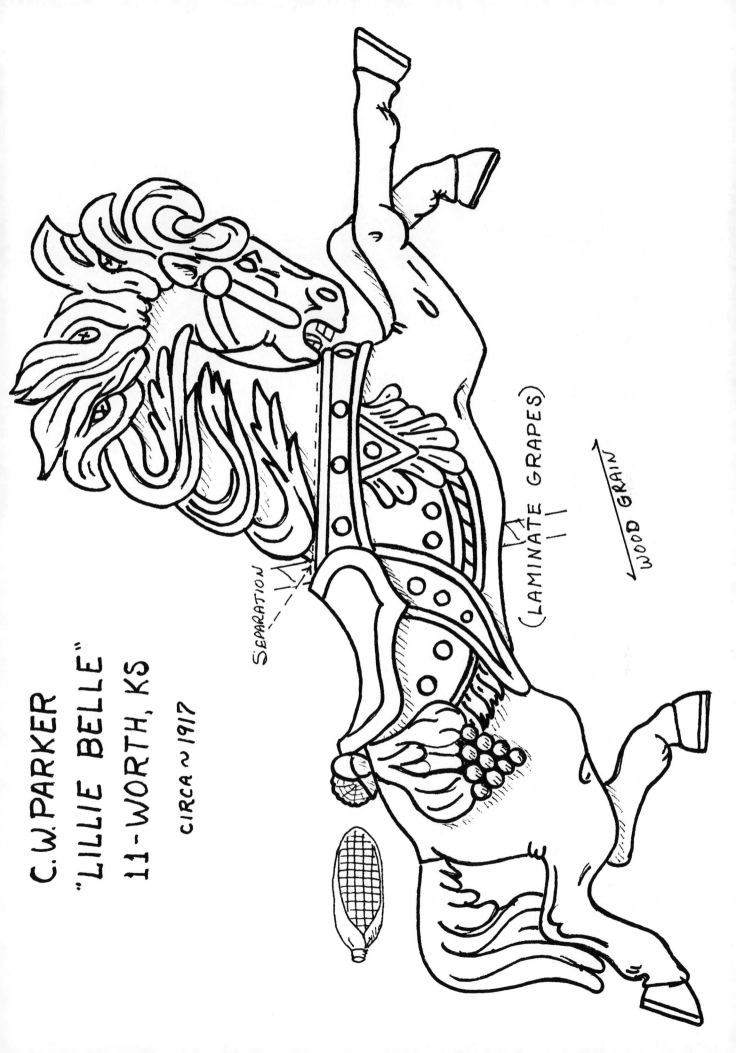

C.W.PARKER
"LILLIE BELLE"
LL-WORTH, KS
CIRCA ~ 1917

SEPARATION

(LAMINATE GRAPES)

WOOD GRAIN

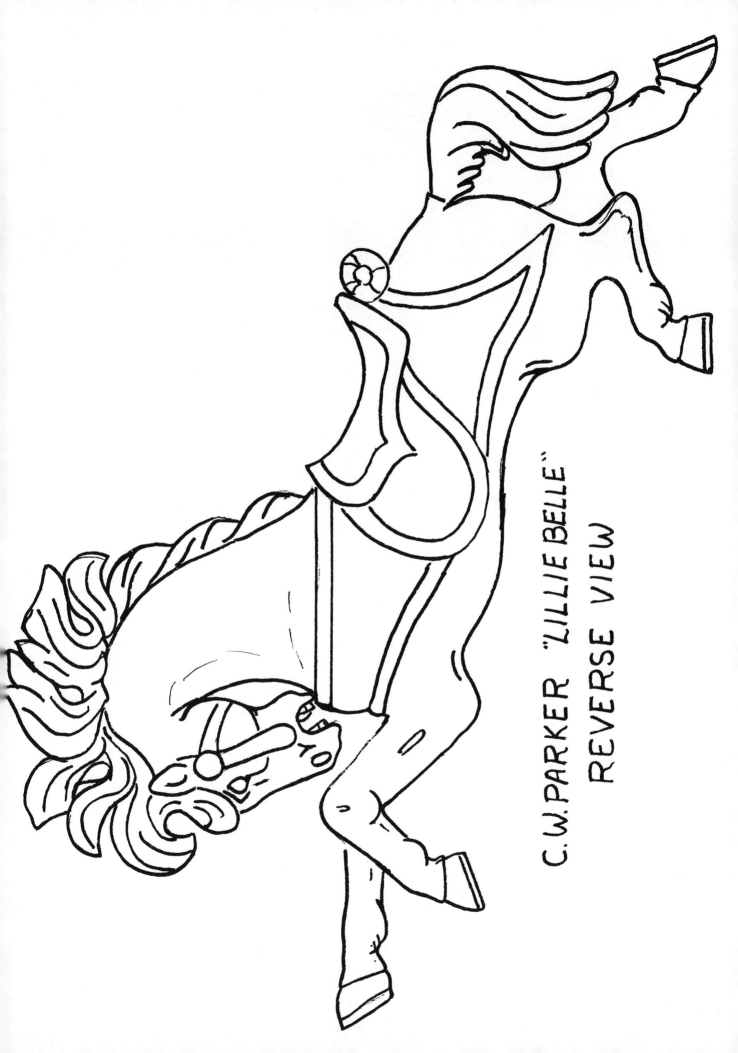

C.W. PARKER "LILLIE BELLE"
REVERSE VIEW

Chapter 10

C.W. PARKER'S AMERICAN BEAUTY ROSE

Parker had at least one row of two or three-horses covered with flowers on most of his carousels. In his catalog, it was called the "American Beauty Rose." It was sometimes also called his "Queen Horse," and it rode on the opposite side of the carousel from the "King Horse." This was one of the two prettiest and most ornate horses on the carousel.

CARVING HINTS

1. The "Rose" horse (it has two roses behind the saddle) is carved very much like the flag horse. The primary difference is that the head is tucked and twisted to the right. The body, neck, and head should be traced onto the wood as three separate pieces. I like to cut these pieces so there is only a small separation between pieces, and therefore, the grain lines up and you don't have difficulty later in carving through the joint. When cutting the blank out on the bandsaw, cut out the body, the neck, and the head so that you have three separate pieces. Cut to the outside of the division cut line on each of the pieces so that you will have enough wood to sand each place that is to be joined so that it is absolutely smooth. See figure 87.

2. Carve all of the details of the teeth, lips, and nostril areas and also the front legs before gluing the head and neck to the body. It is much easier to carve while it is separated. (Be sure to carve the tic-tac-toe (#) design on all the surfaces to be joined, as shown in figure 87.)

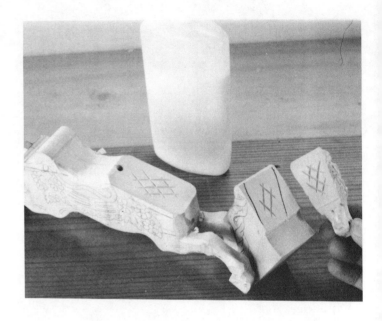

figure 87: The "Rose" blank is started as 3 separate pieces. Carve the details into the head and front legs before gluing the parts.

Carve the tic-tac-toe design (#) into the centers of each of the sections to be joined.

3. *Do not carve the neck piece or the place where the head joins the neck until after the two parts are joined together.*

4. Before gluing the head and neck on the body, check to see how everything fits. The joints should be tight, with no spaces and no rocking motion. The neck should be twisted about 10 degrees to the right of the body, and the head about 10 degrees to the right of the neck. When properly set up, the left nostril of the horse should be over the outside of the right knee, as shown in Figure 87 on the following page.

51

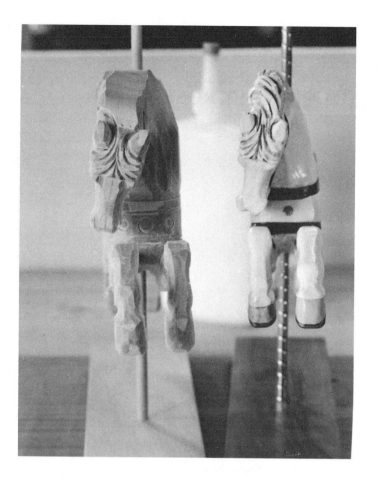

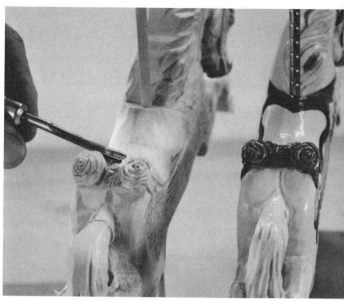

figure 89: The roses behind the saddle are carved with a V-tool. Start with half a football shape , and carve each petal so that they overlap each other.

figure 88: The neck should be turned about 10 degrees on the body, and the head another 10 degrees on the neck. The left nostril should be over the outside of the right knee.

5. Drill small starter holes through the mane and then enlarge them with a small knife to get the "peek-a-boos."

6. The roses behind the saddle should be blocked out to sort of a half football shape and then the rose petals carved in with a small V-tool. Look at a rose, if you can, before carving. It is a series of overlapping petals, wrapped around the center, as shown in figure 89, above.

7. The flowers and leaves which appear on the romance side of the horse are only slightly raised above the rest of the carving. Outline the flowers and leaves with a small V-tool, and then carefully create the "illusion" of greater depth by shaving down the background with a small skew. The flower centers can be made with the "eyeball" tool or a large nail set. See figure 90 on the following page

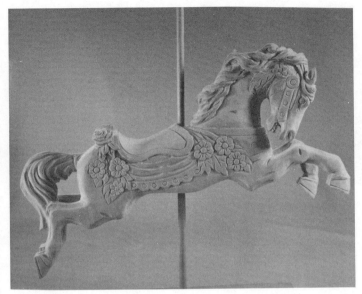

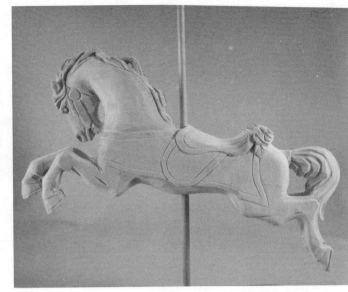

figure 90

figure 91

ILLUSTRATIONS FOR THE C.W. PARKER *"AMERICAN BEAUTY ROSE"*

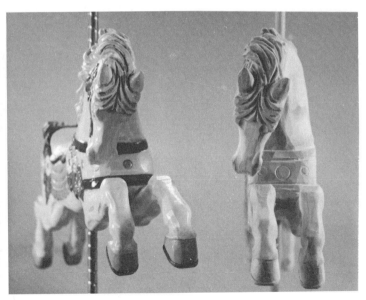

figure 92

figure 93

C.W. PARKER ~ 11-WORTH KS
"AMERICAN BEAUTY ROSE"

CIRCA ~ 1917

SEPARATION

¼" HOLE

SEPARATION

WOOD GRAIN

TWO ROSES

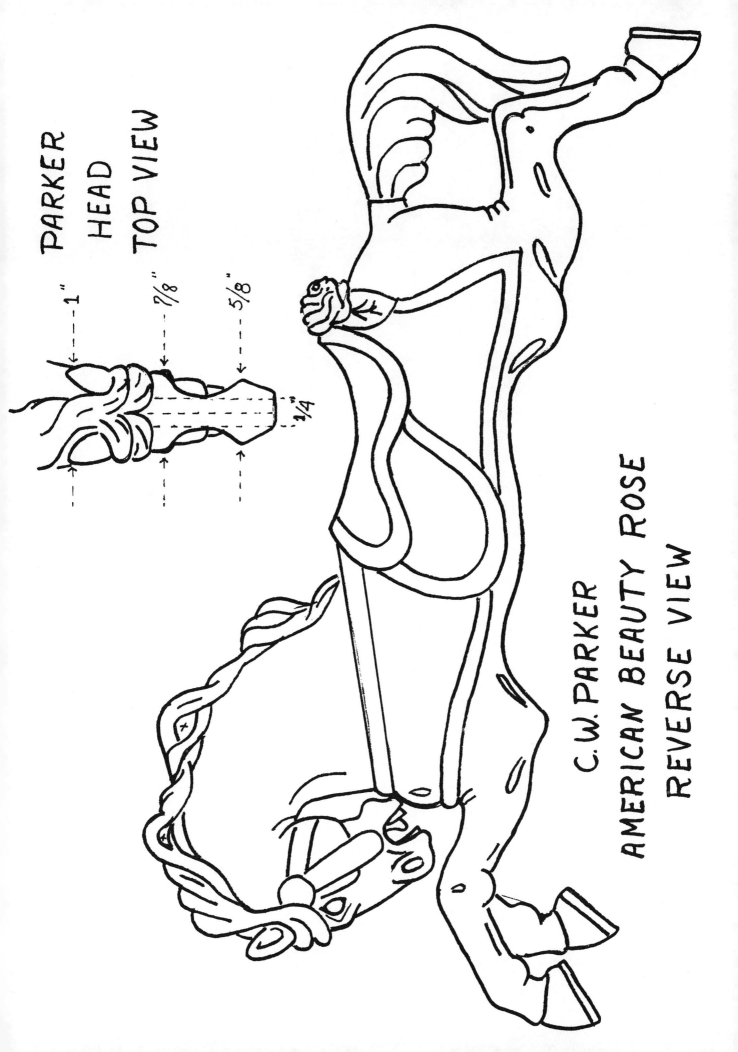

PARKER
HEAD
TOP VIEW

1"

7/8"

5/8"

1/4"

C.W. PARKER
AMERICAN BEAUTY ROSE
REVERSE VIEW

ALTERNATE PATTERN —
C.W. PARKER'S "PEGASUS"

"Pegasus" is almost identical to the "Rose," except for the trappings. You should note that, not only does the mane lack any "peek-a-boos," there is a different flow to it entirely. This mane was also sometimes used on the "Rose" as an alternate look.

The wings were carved on both sides of the horse, but the face and jewels were only on the romance side.

There are no laminations on either design; details are carved into the body block.

The pattern for the C. W. Parker *"Pegasus"* follows.

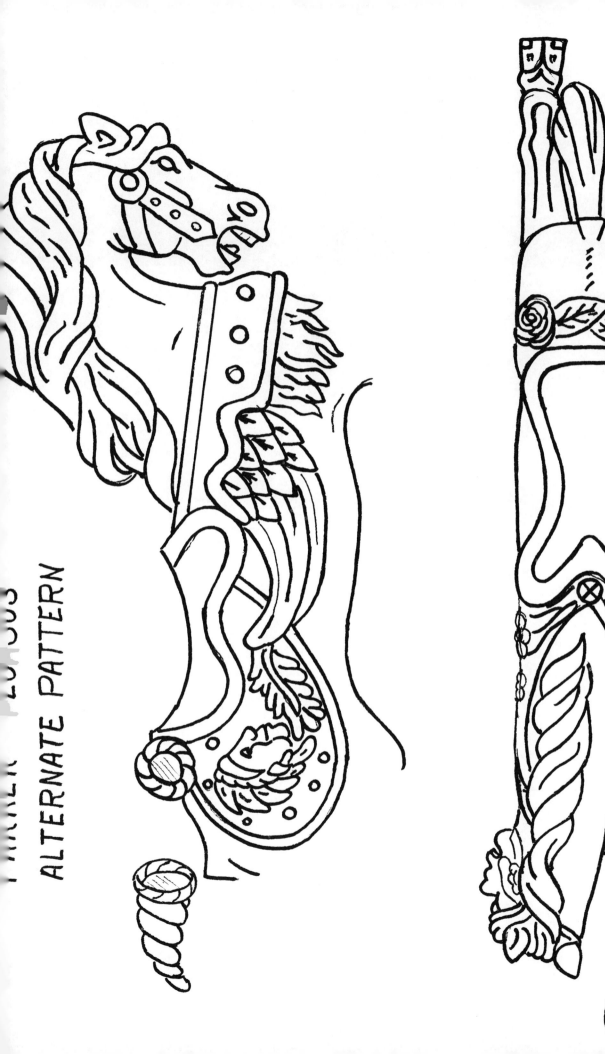

ALTERNATE PATTERN

PARKER "ROSE" ~ TOP VIEW

Chapter 11

SPILLMAN ENGINEERING CAROUSEL HORSES
(1920 – 1930)

The Spillman Engineering Company was part of an evolution of carousel companies located in Tonawanda, N.Y. The company originally started as the Armitage-Herschell Company, a machine shop and foundry. As a side-line it began manufacturing small portable track machines with 24 wooden horses in about 1883. In 1903, the company became Herschell-Spillman, and expanded into building both portable carousels and some large park machines. In 1911, Allan Herschell went into partial retirement and finally left the company in 1913. The H/S Company continued to manufacture both portable and permanent park machines. But by 1917, they were heavily involved in the war effort and manufactured aircraft engines and other war materials for World War I. Carousel production was nil during that time. In 1920, the company reorganized as a corporation, dropped "Herschell" from its name and became Spillman Engineering Company.

They built a new factory on the site of the old Armitage-Herschell plant, and began manufacturing large ornate permanent park carousels accented heavily with menagerie animals. They also continued to produce portable carousels for that very competitive market. This continued until about 1930 when aluminum was introduced into carousel manufacturing. At first, they continued to manufacture horses with wooden bodies and used aluminum legs, neck, and heads on their figures. Shortly afterward, however, the figures became all aluminum and no more wooden carousel figures were produced.

CHARACTERISTICS OF A SPILLMAN

ENGINEERING HORSE

1. Early Spillman horses often had real horse-hair tails. Sometimes, these were replaced with wooden ones. Later, horses normally had wooden tails.

2. They had the "look" of a long body, but with well-proportioned, slender legs. The legs were not heavily muscled, but were well-rounded and smooth-looking. The neck often appeared too short for correct proportions.

3. The ears were simple, laid-back, and well protected with the mane or other trappings.

4. The nostrils were small, but well carved. The tongue was usually flat behind the lower teeth. The chin was small, but the horse had heavy lips. The eyes on the early Spillmans were often carved from the wood; later horses had glass eyes.

5. The Spillman saddle was distinctive. It was long, and came well back and over the rump and was rather plain, with no elaborate trappings carved behind the cantle. The saddle skirt was part of the seat of the saddle and it was all held in place with a simple girth.

6. The horse had metal horseshoes. Three parallel short gouge marks were carved on the back of each hock to simulate the "feathers" of the horse.

7. The manes of the portable carousel horses were plain, pulled to the right, and had a

"plastered down" look. The larger park animals, which were carved later, had more realistic twisted locks in their manes.

8. Spillman horses sometimes had a carry-over in design from the Herschell-Spillman era in that they had what looked like a "bullet butt." The rear of the horse had a distinctive pointed rump that resembled the tip of a bullet. The newest patterns by Spillman Engineering did not have this characteristic bullet shape.

9. All of the carousel figures carved by the Tonawanda, New York carousel factories were carved from poplar wood, not linden (or basswood), the wood commonly used by the factories to the south.

SPILLMAN ENGINEERING ARMORED JUMPER

CARVING HINTS

1. The Spillman armored jumper is carved from three pieces of wood: (1) the head-neck-body and (2) the battle axe (shown in figure 93 below), and (3) the pointed spear head on the front of the armor (which is made from a 1/4-inch dowel and inserted into the forehead of the animal.)

2. The Armored Jumper is one of the few carousel horses which does not have its head twisted to one side. Therefore, the entire silhouette of the head and body can be cut out on the band saw in one piece. The grain of the

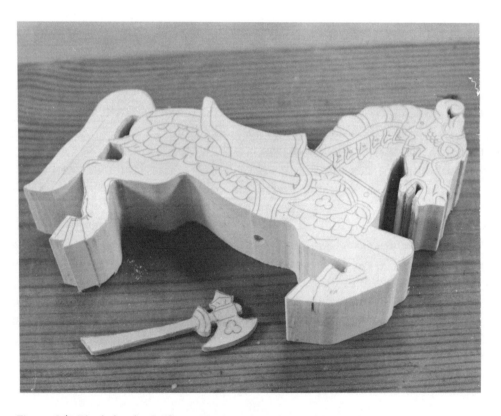

Figure 94: Blank for the Spillman Engineering Armored Jumper. (Note that the battle axe is cut out separately.) The spear point protruding from the front of the head armor is shaped from a small wooden dowel.

59

wood should be vertical to the body of the horse, in this case.

3. When separating the legs, carefully carve between the rump and the tail so that the tips of the fringes at the back of the armor touch the tail for strength and support. It is easier to carve in this area with gouges that have a shank at least 5 to 6 inches long. Carve the inside of the armor between the legs as thin as you feel safe doing, without losing the entire piece. I usually leave about 1/8 inch of wood.

4. The battle axe is cut from sheet stock 1/8 inch thick. The axe is held in place with a flap of part of the saddle over the axe handle. When you cut out the axe, be sure to cut out the flap of leather on either side of the handle. This gets carved down at the edge to look like it flows right into the saddle. Cut the axe out so the grain runs in the same direction as the body of the horse. Glue the axe on with a thin coat of glue and clamp it for several minutes.

5. The pointed spear head protruding from the front of the head armor is made from a 1/4-inch wooden dowel. It can be carved, but I usually just take a length of dowel and grind a point on one end with a belt grinder. If you spin the dowel between your fingers, it is almost like working with a lathe. The shaft of the spear can be ground down the same way. (Be a big spender and grind down at least an inch of shaft behind the point. It gives you something to hang onto while you are working.) I try to make the shaft about 1/8-inch in diameter or the same size as any small wood bit that you have. Clip the shaft to about 1/2 inch. Drill a hole in the forehead of the horse and glue the shaft into the forehead.

6. The fish scales of the armor are carved with a small V-tool. (If you intend to paint the carving when it is finished and you have a wood-burning pen, you may find that using that is easier for detailing on the armor.)

Figures 95, 96 97, and 98, which follow show the Spillman Armored Jumper)

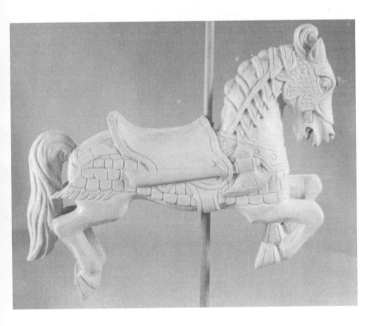

figure 95

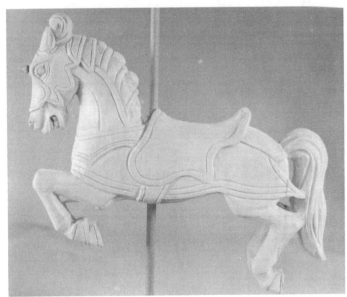

figure 96

ILLUSTRATIONS FOR THE SPILLMAN *ARMORED JUMPER*

ILLUSTRATIONS FOR THE SPILLMAN *ARMORED JUMPER*

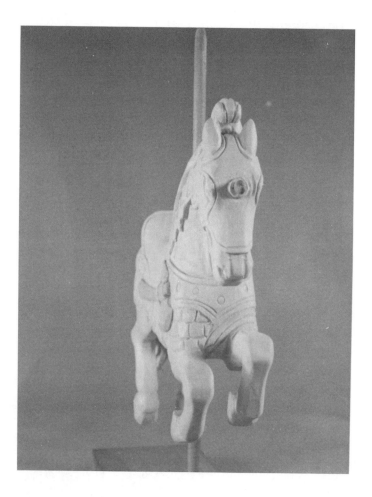

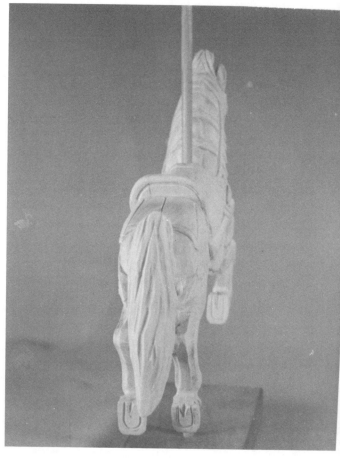

figure 97 figure 98

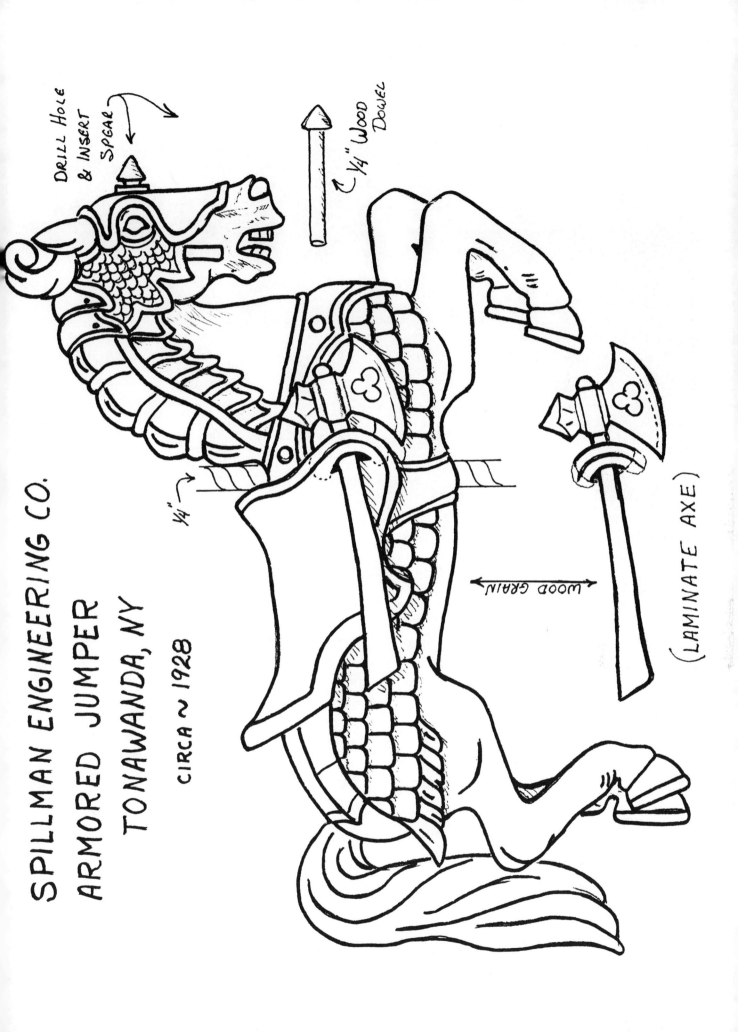

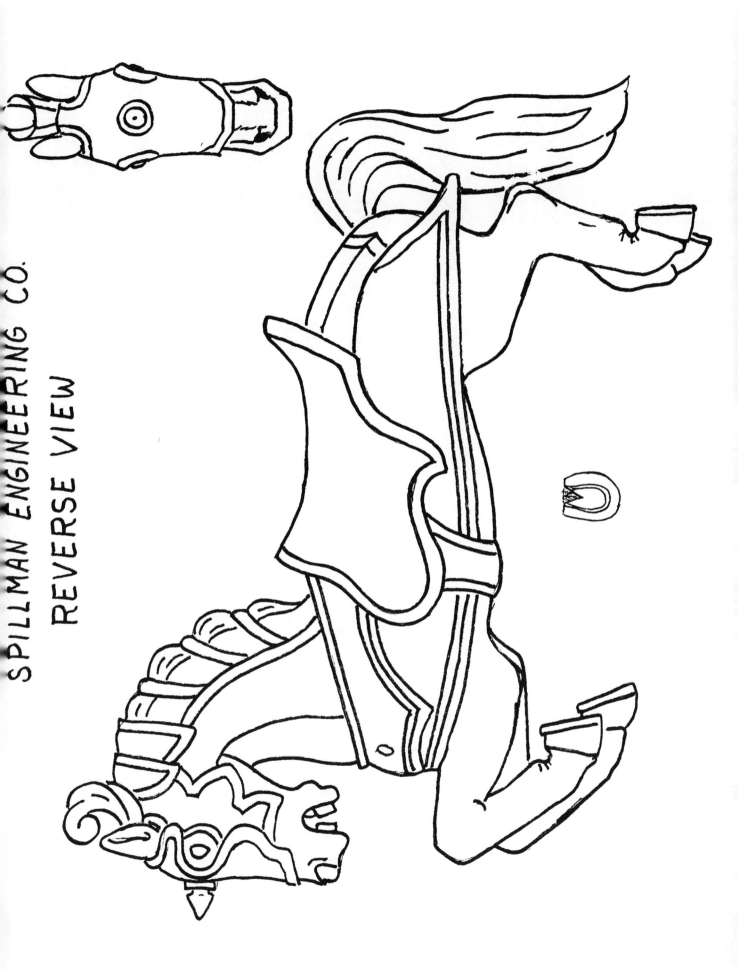

SPILLMAN ENGINEERING CO.

REVERSE VIEW

Chapter 12

ALLAN HERSCHELL
(1915-1931)

Allan Herschell was one of the original founders of the Armitage-Herschell company of Tonawanda, New York which later became the Herschell Spillman Company. Allan Herschell retired from Herschell Spillman in 1911 and was dropped from the company's rolls as a retainer in 1913.

In 1915, Allan Herschell came out of retirement and formed his own company, which was located just a few blocks from his old factory in Tonawanda. He was in direct competition with Herschell Spillman (later Spillman Engineering Company), where he used to work. He started his new company with some old long-time workers from his original plant.

During the years of World War I, carousel production slowed down to almost a standstill. But by 1919, the Allan Herschell factory began a major production effort on two and three row carousels. There was a strong similarity to the horses produced by Spillman Engineering, but even so, his horses managed to have their own unique "look."

Allan Herschell retired again in 1923, due to poor health, and the factory was run by John Wendler (one of his original employees from the old business). In 1927, Allan Herschell died at the age of 76 and Wendler took over the reins at the company. In 1931, the Allan Herschell Company begain to follow the popular trend and began manufacturing aluminum horses, marking the end of the wooden carousel horse era.

The original Allan Herschell Factory is now a museum in North Tonawanda, New York. As one of the main attractions, it has an operating Allan Herschell carousel. This carousel is a 1916 version with 36 jumpers, a chariot, and a lover's tub. It has many of the roached mane jumpers similar to the one in this book. Many carousel figures carved by the A/H factory are on exhibit, and some of the old machinery is still there as well. (Their mailing address is P.O. Box 672-180, Thompson Street, No. Tonawanda, NY.)

CHARACTERISTICS OF ALLAN HERSCHELL CAROUSEL HORSES

1. The most distinctive feature of the Allan Herschell horses was their chunky bodies and over-sized heads. Short-chopped wooden tails were the norm. The rear legs were gathered under the body and the front legs were often tucked up close to the body as well. Some say that the inspiration for this look was Frederick Remington's paintings of western mustangs.

2. The large heads had what is known as a "Roman" nose, rounded down slightly from the eyes to the nostrils and rounded sharply from the nostrils to the lip.

3. All of the horses had carved wooden eyes. Glass eyes were never used on these horses.

4. Early carvings by the Allan Herschell Company were more ornate that the later ones (carved from about 1920 on). The earlier carvings seemed to be more for park machines and were highly detailed; but none of the early Allan Herschells are still in operation. Many A/H carousels carved after 1920 are still spinning,

but the trappings are not as elaborate as those that appeared on the earlier carvings.

5. On outside row horses, the trappings were usually in multiple layers and levels of blankets and saddle skirts. Glass jewels were used extensively. The saddle itself was almost flat when viewed in profile. The pommel was sightly raised around the pole hole, but the cantle was low, and had no decorative carving.

6. Inside row horses usually only had saddle blankets with carved designs, but did not have saddles. The blankets usually had a fold carved into the back that raised the rear of the seating area slightly. It is presumed that this was to keep people from sliding too far back and falling off the rump of the horse.

7. All the horse shoes were metal, and sometimes real horseshoes were used.

8. "Feathers" were carved behind the hocks, usually with three grooves.

9. The ears were simple; they were laid-back and close to the head.

10. The classic "trojan" mane was usually featured on what was considered the "lead-horse," but other horses had long manes, which were usually pulled flat in detailed strands along the side of the neck.

11. The teeth were large and the horse's mouth was wide open with a flat tonge behind thick lips, but a very small chin.

figure 99: Blank for the Allan Herschell Trojan Jumper. Note the four pieces of wood. Be sure the wood grain is all in the same direction.

12. The legs are well-rounded and there was not much muscle detail, except on the back of the rear legs.

13. All of the figures carved by the Allan Herschell Company were done in poplar wood.

ALLAN HERSCHELL TROJAN JUMPER

CARVING HINTS

1. The Allan Herschell trojan jumper is the most difficult carving in this book. The head must be twisted so that the nostrils and lips of the horse are outside of, and overlap, the right front leg and shoulder.

2. The trojan horse is carved from four pieces of wood: (1) the body, (2) the neck, (3) the head, and (4) the forehead tassel, as shown in figure 99, above.)

3. The grain of the wood should be vertical to the length of the body to give more strength to the legs.

4. Since this horse does not have a harness line to hide the neck cuts, it is very important that all the surfaces that will be glued together be sanded to a glass-like smoothness. Test the pieces often to make sure there are no deviations.

5. Carve the head first, except for the area where it joins the neck. Then carve the chest and the front legs. See figures 100 below.

6. The head has to be racked over to the right in order to fit. Try the fit without glue at first to make sure the neck and head are each twisted enough. Mark the head position on the neck, and score both surfaces with the tic-tac-toe (#) cuts. The head should be glued into position a little past the 7:00 o'clock position on the neck. Now score the neck and shoulder surfaces and glue them into position, making sure that the nose of the horse is clear of the right front leg and that the forward part of the neck lines up with the front of the chest. (See figure 101, above right.)

figure 101: When glued together, the nose of the horse must be outside of the right frong leg. The front of the neck block should be even with the front of the chest.

7. Draw the jugular from the center of the chest in a curve up to the center of the throat area. Hollow it on both sides with a small, deep gouge. Carve off the excess wood to make the neck flow into the chest.

8. The trojan mane is wider at the top than it is at the roots. The top of the mane is about 1/2-inch wide, separated by divisions in the hair. Undercut along the top of the mane with a gouge to create a shallow depression on both sides. Then score in the detailed hair cuts with a V-tool. The top of the mane just has some random cuts in various directions to give it a rough look.

9. Glue the tassel in place on the forehead and finish the carving.

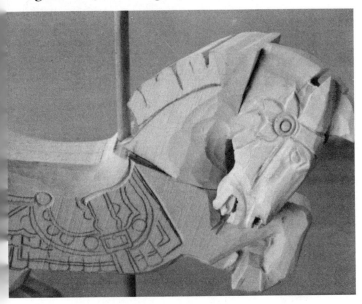

figure 100: The head detail should be completely carved while the head is detached.

66

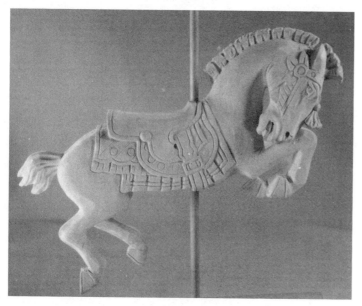

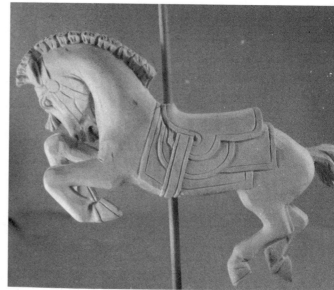

figure 102

figure 103

ILLUSTRATIONS FOR THE ALLAN HERSCHELL *TROJAN JUMPER*

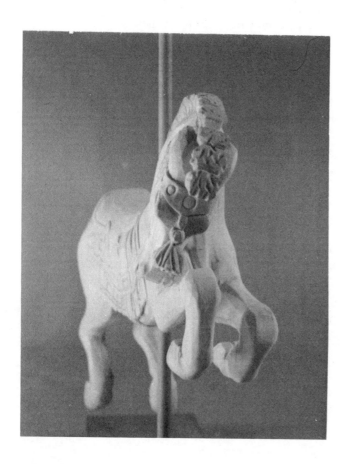

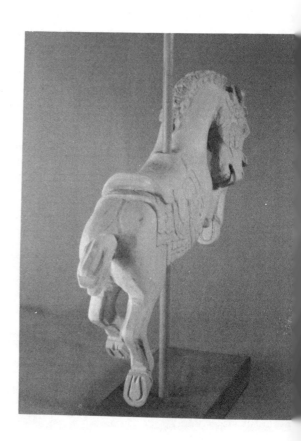

figure 104

figure 105

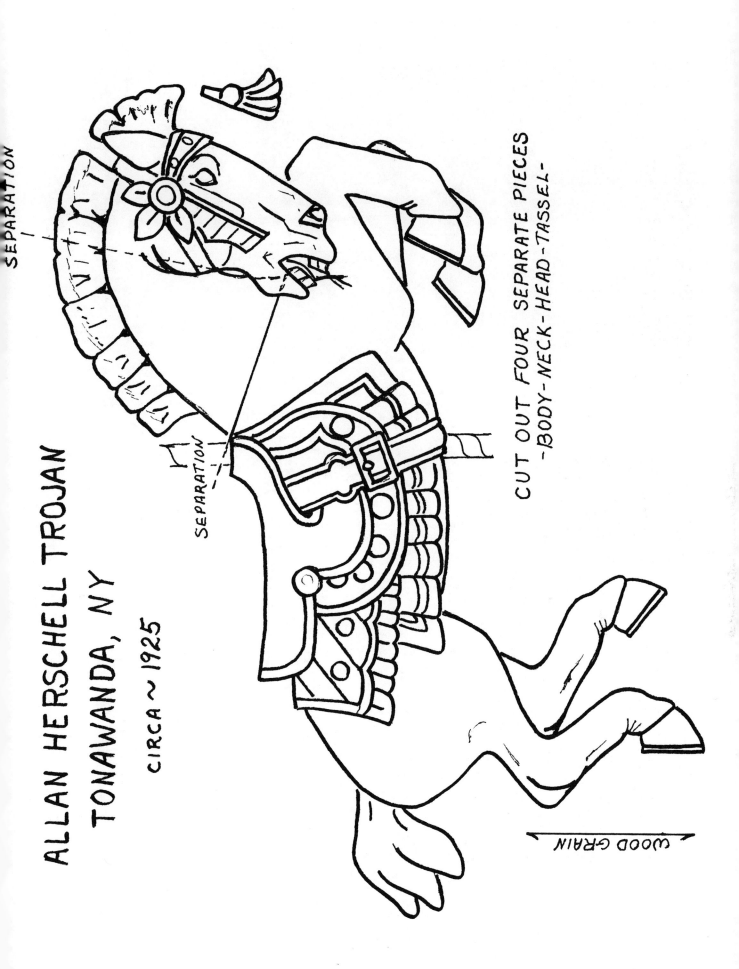

ALLAN HERSCHELL TROJAN
TONAWANDA, NY

CIRCA ~ 1925

SEPARATION

SEPARATION

CUT OUT FOUR SEPARATE PIECES
—BODY—NECK—HEAD—TASSEL—

WOOD GRAIN

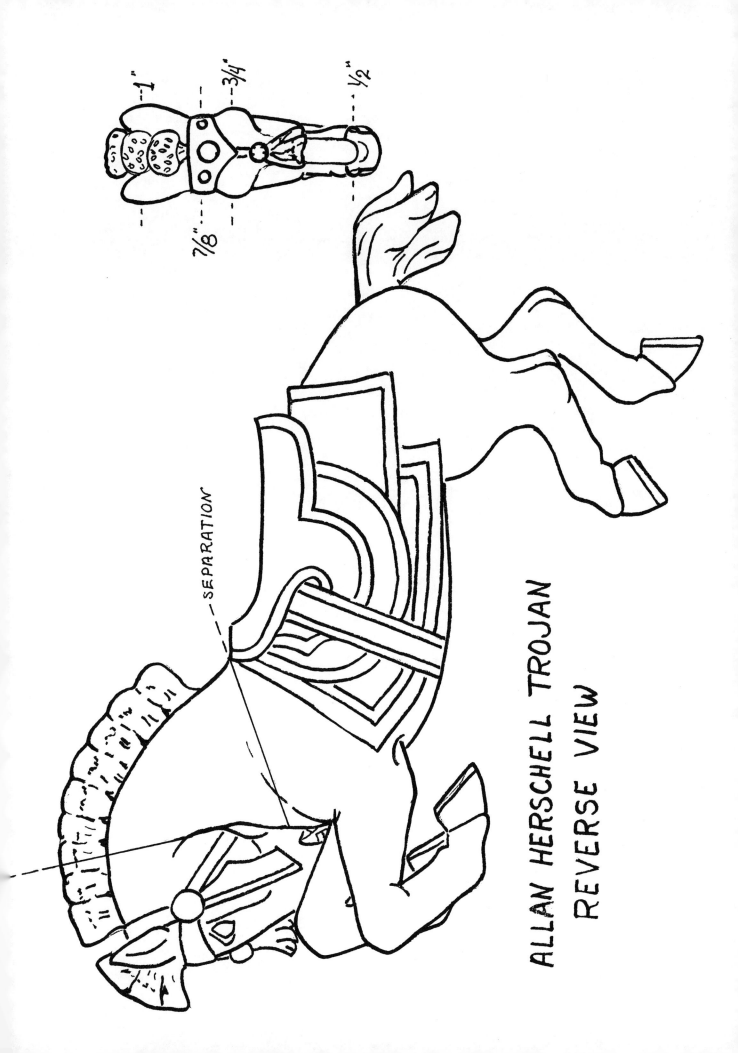

1"

3/4"

1/2"

7/8"

SEPARATION

ALLAN HERSCHELL TROJAN
REVERSE VIEW

ALTERNATE ALLAN HERSCHELL PATTERNS

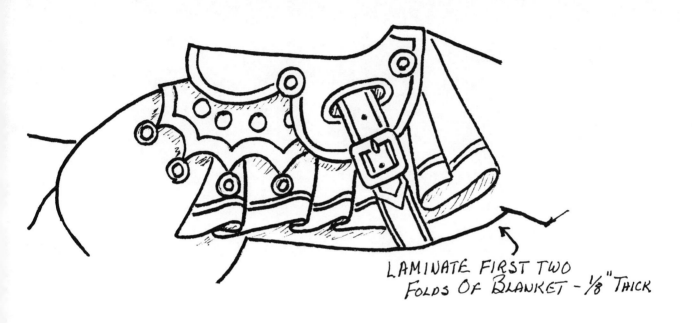

LAMINATE FIRST TWO
FOLDS OF BLANKET - 1/8" THICK

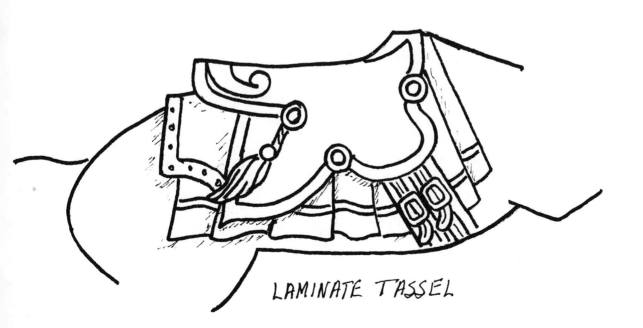

LAMINATE TASSEL

Chapter 13

PAINTING AND FINISHING A CAROUSEL ANIMAL

HISTORIC NOTES

The artists that painted the old wooden carousel animals in the various carousel factories were true masters. Unfortunately, few animals or carousels have that original artwork still visible. (Philadelphia Toboggan Company #6, Kit Carson County, Burlington, Colorado is beautiful in original paint.) Many carousels that needed touch-up paint at the end of the year were given to the local flunky who would then dab a little of whatever paint was available over the worn spots. Most of the time, the original paint was just covered over. The paint that is on the animals now is known as "park paint."

All of the carousel animals on the old carousels were painted. Stains were not used. Most of the paints used at the time (1867 - 1930) are no longer available or are considered unsafe for use by today's standards. Often, lead-based paints were used. Sometimes, Japan-paint (a type of oil-base paint) was used and it is still available. Milk-paint (where the colors mixed with milk) was very often used to paint the body of the horse and was very durable. But almost any paint that was locally available or handy was used by park workers when they did their seasonal touch-ups, from house paint to watercolors. If you ever have the opportunity to strip an old park-painted animal down, be very careful handling that old paint. It can be very harmful if you get it into your lungs, so wear a mask.

Today, I use both stains and acrylic paints to color my carousel animals. While the stains are not authentic, there are some beautiful colors available, and the transparency of the stain allows the wood grain to show so people will know that it is a wood carving. (Very often, I have been asked if my carousel horses are really wood or if they are ceramic or porelain —- to a woodcarver, that is irritating —- especially at a woodcarving show!)

THE FINISHING PROCESS

Before starting to paint or finish the carving, make sure that the carving is finished. By that, I mean that all of the loose cuts have been cleaned up and there are no rough spots or saw marks on the carving. Also, be sure to clean off the dust and grime that just accumulates there from handling your carving with your hands as you work. Use a Sand-o-Flex with a very fine grit filler to clean it up. Again, check the carving to make sure that no detail was inadvertently wiped out.

WARNING: A carving that looks like a fuzzball will not look any better with paint and stain on it. Paint or stain will not cover up sloppy carving. In fact, it may make the carving look even worse. *Be sure your carving is ready to be finished before you go any further.* The painting and finishing of your carousel figure should be done with just as much care and time as you devoted to the actual carving.

There are many good ways to finish wood. Everyone seems to have his own personal preferences and favorite products. If you are already happy with a system that works for you, I would recommend that you stick with it. It is always better to go with something you know how to use, and with which you are

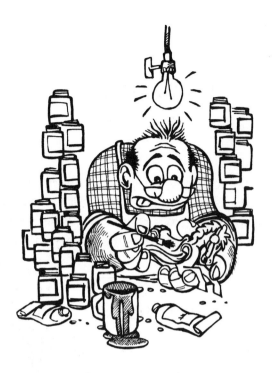

figure 106: Painting and finishing your horse requires as much care as it took to carve it.

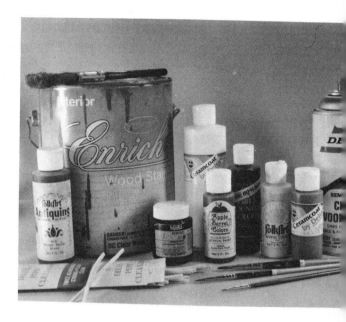

figure 107: Some of the painting, staining, and antiquing materials we always use to finish a horse.

familiar, than to experiment with an unknown element.

My wife, Marilyn, and I work together on the painting and finishing. That means she gets to do the part that is fun and I get all the nasty stuff. Occasionally, I do get a chance to do some painting (the fun part) just to keep my hand in!

PRODUCTS USED IN FINISHING THE CAROUSEL FIGURE

We use ordinary finishing materials that you can buy in any hardware store, paint supply, or hobby shop. See Figure 107, which follows above, right.)

1. If we use stains, we use *oil-base, penetrating stains..* I have a few favorite colors, some of which are nutmeg, warm provincial brown, or golden oak. I personally don't like very dark stains. You decide what you like best to highlight your own carvings.

2. We use DEFT semi-gloss clear wood finish in a spray can to seal, separate finishes, and provide the final coat.

3. We use *acrylic* water-based paints in a wide variety of colors to paint the trappings and often the horses as well. The brand is not important; they all mix and seem to paint about the same. (We do prefer the plastic bottle containers rather than tubes, because you waste less paint and they are easier to use and store.)

4. I also use brown *acrylic antiquing* by "Folk Art." It is usually available wherever you buy your acrylic paints.

Other materials to have on hand are many small paint brushes, soft absorbent paper towels, soft pipe cleaners, and the old SAND-O-FLEX. We have found that we like sable or camel hair brushes best. The quality of these brushes pays off. Cheap brushes will shed (leaving their hair embedded in the paint) and will not last very long.

72

STEPS TO FINISHING

FIRST: Decide on a color scheme. Carousel horses were painted all kinds of colors. I have seen them painted green, red, blue, and even with polka dots. I don't recommend those colors. A white horse gives you the most options of attractive accompanying colors. I do not recommend ever painting a horse black. It will make the horse so dark that you will not be able to see any of the detail that you have spent so much time carving into it. If you want a dark horse, use charcoal or dark grey rather than black. Light colors are usually best. The trappings and decorations can be a rainbow of colors or a blending of just a few coordinated shades. We like to use a lot of gold wherever possible. It adds a lot of flash and it was used often on real carousel figures. The natural color of the wood can be left to effect a pale palomino color also. To see if you like that color, just wet your finger and rub a spot on the raw wood. This is approximately the same color the wood will actually be once it is sealed with the DEFT lacquer.

SECOND: Decide whether you want to use stains for the body of the carousel figure.

IF YES — apply the oil base stain to the raw wood on the part of the hose you wish to stain. If the stain is to go onto only a small area, I use soft pipe cleaners to apply it and then throw them away. (as shown in Figure 106.) If most of the animal is to be stained, I often dip the whole figure into a bucket of stain. Then I wipe off the excess stain using absorbent paper towels. (I use JOB-SQUAD brand.) I find that this technique is much faster. Let the stain dry for 24 hours. The first coat of anything you put on raw wood is going to raise the nap of the wood up, so it will feel rough and tacky. Use a SAND-O-FLEX to slick the carving back up where the stain has raised the nap of the grain. The SAND-O-FLEX does something else for stained figures. It takes off a little bit of the stain

on the high spots, leaving the deeper cuts darker. This gives the stained figure more definition and life and shows the carving off to a better advantage. Spray and seal the stained carving with three coats of DEFT (use the spray variety in the clear wood finish). Allow at least 30 minutes of drying time between coats.

figure 108: Staining the "horse" part, using a pipe cleaner and oil-based stain.

IF NOT — When not using stains, you must spray and seal the wood with at least 3 coats of DEFT to prepare it for painting. After the first coat of DEFT, use the SAND-O-FLEX to smooth the nap that will be raised. Then finish spraying on a good sealing coat of DEFT.

After your carving has dried, carefully rub it all over with your hands, feeling for any rough spots. If you find any rough spots, re-apply the SAND-O-FLEX and repeat the application of DEFT. When you are ready to paint, the finish on your carving should feel "as smooth as a baby's bottom."

You are now ready to paint the detail.

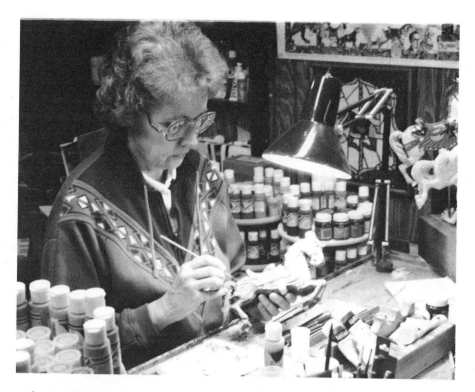

figure 109: Marilyn, at her paint table, applying acrylic paint to a figure. Notice the drying stand on the right, paint, water, and brushes in front, and paint bottles everywhere.

YOU ARE NOW READY TO PAINT THE CARVING

Select the colors you want to use on your carving. If you have not stained the body of the hose, I always paint that first, using acrylic paint. If you paint the body of the horse, you should seal that with another coat of DEFT before going on. (This will allow you to clean up any mistakes without having to repaint the horsehide.) Acrylics take about 15 minutes to dry to the touch. Marilyn and I usually paint five horses at once so that by the time we have put paint on Number 5, Number 1 is dry enough to continue working on. All acrylic paints are compatible, will mix well with each other to create different shades, and are thinned and cleaned up with water. You will also need some good quality small brushes. Different sizes should be selected depending on the amount of detail you have put into your carving. If you keep your brushes clean with water, they will last a long time.

If you get a little sloppy or make a mistake by putting paint where you don't want it, use a Kleenex tissue dampened with water to just wipe it off. But remember that acrylic paints dry fairly quickly (within five minutes), so don't delay in your clean-up job.

Acrylic paint must be used with water. Dip your brush in water before dipping it into the paint. The water acts as a thinner. The more water you use, the thinner the cover of color. Acrylics can be applied in such a way that they are almost translucent. Using less water will produce a heavier, more solid coat of paint. Usually we use at least two coats of paint for each color.

When painting a figure, double coat all of the lighter colors first. The parts that are silver or gold metallic are included in this first group. Medium and dark colors are double coated next, in that order. Give each coat of paint at least 10-15 minutes to dry before applying a second coat.

Jewels should be painted last. Use a tiny brush and paint very carefully. We use metallic acrylic paint for all jewels. They come in all colors and have a high lustre.

You might want to try permanent ink pens for pin-striping, lettering, or particularly tiny detail work. Test the pen first by marking it on scrap wood and spraying it with DEFT to make sure the two are compatible. Some pens will fuzz or run when sprayed with DEFT. You want to find that out before it happens on your carving.

Eyes are painted in burnt umber acrylic. Then a tiny dot of white paint is added —- off center—- for a highlight.

Light ivory acrylic paint is used for the teeth. The color "rouge" is used to paint the tongue and mouth of the animal.

SEAL WITH DEFT

When you are satisfied with your painting, you must seal the figure once more, with DEFT. I like to give the paint at least 24 hours to dry before I seal it, but if the paint has not been brushed on too thickly you can do it sooner. Give it at least two, preferably three coats of DEFT to seal the paint. The sealer is to protect and separate the paint from the antiquing. I use a dowel stick inserted into the pole hole to hold the horse up while I am spraying it. I spray right side up first, then upside down after the first coat has dried. Repeat until a good seal is attained. Be sure to spray into the hard-to-get-to areas, like between the legs, under the chin, and into the mouth.

ANTIQUE YOUR FIGURE

I use acrylic antiquing by "Folk Art," for this step, in a color called "Wood'n Bucket Brown." You can buy it the same place you buy your other paints. I antique the figure to make the carving stand out more clearly. I squirt some antique medium out on an old TV dinner plate I use for a pallet, wet a 1-inch wide latex paint brush in water, and slop the goop all over about 1/3 of the figure. Antiquing acrylic works the same as the paint. The more water is used, the thinner the cover. I usually use a thicker mixture in areas where I want the carving to really stand out. Then I use JOB-SQUAD paper towels to try to wipe it all off. (I use this brand, available in grocery stores here in Kansas, because it is a heavy absorbent paper towel that does not leave fuzz on the carving. If JOB-SQUAD is not available in your area, test out the various brands until you find one with the same qualities.) Then I repeat the antiquing process on the next third of the figure and so on. Check the piece in a good light (sunlight is best), and make sure there are no goofs from the antiquing. A little clean water on a wet towel will clean up most goofs you may find. There should be only a trace of the antique goop left on the figure, usually down in the deeper cuts and separations of levels on the carving.

After allowing the figure to dry for several hours, you can begin spraying the final coats of DEFT on your carving. Another three or four coats are necessary. CAUTION! Do not do this final spraying when there is a lot of humidity in the air. It will fog the lacquer and make the finish look milky. If this inadvertently happens, stop and wait for a dryer day. Then spray with DEFT again and the new coat of spray will pull the fogged look out of the carving.

A word about DEFT...

DEFT is basically a lacquer. I like it because it dries absolutely clear and does not discolor the acrylics. It is almost fool-proof, too. The only way you can get into trouble with it is to spray on too heavy a coat. This causes drips! So, when you spray, make only one pass with the spray can. Don't go back over the same area again

until you are ready to apply the next coat. You can put on as many coats as you want; just be sure to give it 20 - 30 minutes to dry between each coat.

WARNING: DEFT should be used only in a well-ventilated area and away from any open flames. Wear a mask when spraying. Spray during days with low humidity for the best results. Also, avoid spraying during very cold temperatures. This sometimes causes the finish to "alligator" or crack so that it has the same rough appearance as an alligator's back. Put on eough DEFT to give the carving a smooth, glass-like finish.

MOUNTING THE CARVING

When I started carving my first carousel horses, I mounted them on a 1/4-inch wood dowel that I later painted gold. I carved a little ball decoration on the top of the pole. It is pretty easy to do so. Just sand the dowel a little to make it slightly smaller than the hole in the carousel figure. Slide it in and use a little glue on the last inch to lock it is place. This is easy, cheap, and quick. It looks okay too.

Later, I thought I would get a little classier, so I went to a welding supply store, and bought some 3-foot lengths of 1/4 inch brass welding rods. I cut them into 11 5/8 inch lengths and ground a little ball decoration on one end with my belt sander. But now I had to invest in a cloth buffing wheel and some buffing compound, because the welding rods were pretty dull and needed polishing. But when they were shined up, they did look better than the wooden dowels.

Now, I go to a local machine shop and have them turn a bunch of poles on their lathe to give them a fancy spiral twisting up the pole, and they put a fancier ball on top. They really looked great! But then I discovered I was spending an awful lot of time polishing brass

poles, so I hired a brass shop to polish my poles. Now they are so bright I can see my face in them. But they are much more expensive than my old wooden dowels were.

You will have to make a choice on what kind of pole you want. It should be 1/4-inch in diameter and approximately 11 5/8 inches long. That allows the finished carving to set on most 12-inch shelves.

I always re-ream out the pole hole in the figure, because it often swells shut with the stain, paint, or humidity. I use a 1/4 inch, 18-inch long extender twist bit in an electric drill. The long bit insures that the chuck on the drill doesn't scar or damage the paint on the carving. Always clean out the hole from the bottom up.

Then press the pole up through the belly of the animal until it is in the correct position. (I like the horses to be positioned low on the poles so they aren't top heavy.) If the pole is tight, I just use my own body weight, and carefully push down on a solid part of the body of the animal. It should slide right in.

If the pole is loose, spread a little glue on the pole just before the final inch of it goes into the hole.

The bases themselves can be as fancy or as plain as you like. I usually use a hardwood with pretty grain that I don't have to stain, and just seal it with DEFT. I used to rout the edges, but now I usually just sand them smooth. I always number my carvings and sign them on the bottom with a burning pen. That way, they know who to blame if there is something wrong. (So make sure you don't do anything wrong!) Drill a 1/4-inch hole in a base made of 3/4-inch hardwood. The hole should be as deep as possible without going all the way through. With a wooden mallet, drive the bottom of the pole into the base.

You are finished! Take a few minutes to admire your artwork. —- Then start on your next carousel figure and try to do a better job the next time!

(You will find full color illustrations of the completed carvings in the color section of this book.)

Chapter 14

PAINT COLORS USED FOR THESE CARVINGS

A carousel horse can be painted any colors that appeal to you. There are no standard colors for anything, when it comes to carousel animals. Your own preferences should be your guide. However if you want to duplicate the acrylic colors we used on the five horses in this book, they are listed below.

NOTE: ALL HORSES WERE ANTIQUED USING FOLK ART ACRYLIC ANTIQUING —- "Wood'n Bucket Brown.

PARKER FLAG HORSE

Ceramcoat —- Light Ivory
Liquitex
" —- Gray #7
" —- Rouge
" —- Gray #5
" —- White
" —- Burnt Umber
" —- Kim Gold
" —- 14K Gold
" —- Navy
" —- Fire Red
DecoArt Dazzling Metallics —-
" —- Tomte Red
" —- Shimmering Silver
" —- Blue Jay

PARKER ROSE HORSE

Ceramcoat —- - White
Liquitex
" —- Burnt Umber
" —- Light Ivory
" —- Gray #7
" —- Rouge
" —- Irridescent White
" —- Chrome Green Lt.
" —- 14K Gold
" —- Kim Gold
" —- Empire Gold
" —- Fire Red

PARKER ROSE HORSE (Continued)

DecoArt Dazzling Mettalics —
" —- Ivory
" —- Blue Pearl
" —- Navy
" —- Colonial Blue

PARKER LILLIE BELLE

Ceramcoat —- White
Liquitex
" —- Iridescent White
" —- 14K Gold
" —- Burnt Umber
" —- Bright Yellow
" —- Christmas Green
" —- Vibrant Green
DecoArt Dazzling Metallics —-
" —- Ocean Reef
" —- Green Pearl
" —- Fire Red
" —- Ice Blue
" —- Empire Gold
" —- Shimmering Silver
" —- Rouge
" —- Lt. Ivory
Folk Art Metallic —- Garnet Red

Accent Country Colors
" —- Soft Black

SPILLMAN ENGINEERING ARMORED

Stained "Early American" —- TRU-TEST
ENRICH WOOD STAIN (Tru-Value Hardware
Stores)

Ceramcoat —- Rouge
Accent Country Colors —-
" —- Lt. Ivory
" —- Soft Black
" —- 14K Gold
DecoArt Dazzling Metallics —-
" —- Copen Blue
" —- Ice Blue
" —- Colonial Blue
" —- Spice Tan
Liquitex —- Burnt Umber
" —- Flesh Tan
" —- Iridescent White
" —- Iridescent Copper

ALLEN HERSCHELL TROJAN

Ceramcoat —- Rouge
Liquitex
" —- Burnt Umber
" —- Lt. Ivory
" —- Burnt Sienna
" —- White
" —- Blue Heaven
" —- Terra Cotta
" —- Palomino

Grumbacher Keepsake —-
" —- 14K Gold
" —- Vermont Forest Deep
" —- Blue Pearl
" —- Kim Gold

Chapter 15

MAKING YOUR OWN PATTERN FROM PHOTOGRAPHS

One of the best ways to make your own carousel horse pattern is with your camera. However, a carousel animal on a carousel is often a very difficult photo subject. The lighting and the shadows in the daytime makes it difficult, and all the reflected decorative lights on the machine cause problems at night as well. Setting your camera exposure correctly can be a real challenge. Then to really complicate matters, you will usually find a fence or wall or some other kind of barrier that will get in your way, preventing you from backing up enough to properly frame your photo, as shown below.

figure 110: There are always problems when trying to photograph a carousel!

A couple of years ago, I went to a 28-80mm zoom lens for my camera. It also has a self-focusing automatic shutter feature to help keep me from making any more mistakes. The 28mm wide angle lens allows me to get photos when I am INSIDE the fences. The 80mm end of the spectrum allows me to zoom in on detail OVER the fences. I use the flash on the camera EVERY time I shoot. It takes out the hard shadows in the daytime and lessens the glare from extraneous lights at night.

To make the pattern shot, you need to have the entire horse in the photograph. It won't happen often, but if you are able to, get as far back as possible from the figure you want to shoot, and use the telephoto lens to zoom in and fill up the frame. That will eliminate as much distortion as possible and will save you a lot of guesswork later.

DISTORTION

Any photograph taken of a three-dimensional figure will have some distortion that must be adjusted for before it can be used for a pattern. The camera "sees" the same way your eye sees. The legs farthest from you on a carousel horse will appear to be shorter and slimmer that the legs that are closest to you. This must be corrected when making the pattern so that all four legs are the same size.

If you have to use the wide angle lens to take a pattern shot, it means you are too close and will have to modify at least the chest and rump to give the proper length to the body, as shown in Figure 111 on the following page.

If you photograph a stander, you must lengthen the far legs to reach a line drawn across the bottom of the two romance side feet. All feet touching the ground must have

figure 111: A camera held too close does not "see" around the ends of the figure. The farther the camera is from the subject, the less the distortion.

figure 112: Shows the aiming point for the camera lens

their bottoms on that line. The far legs must also be enlarged to the same size as the romance side legs, even on a jumper.

PHOTOGRAPHING A CAROUSEL ANIMAL

A 35mm camera with a telephoto lens is usually the best camera to use.

THE PRIMARY PATTERN PHOTO. The most important photo is the pattern shot. This picture must be taken at a 90 degree angle from the right side of the animal. If you have a telephoto camera, get as far back as possible and then zoom in to fill the frame. (This will eliminate distortion most effectively.) The camera lens should be even with the upper shoulder, just in front of the saddle. The entire animal should be in the photograph and it should be as straight-on as possible, (as shown in Figure 112, above right.)

SECONDARY PHOTOS. Photographs should also be taken from directly in front, directly behind, and from the reverse side, if possible. Two angle shots of the reverse side

will work if the animal is still on the machine. Take one from the front and rear angles to show all of the reverse side on the two photos.

Take a profile photograph of the side of the head, from both sides. If possible, take a photo of the front of the head as well.

DETAIL PHOTOS. Photographs of any special details on the carousel animal are necessary in order to reproduce them correctly. Usually, a close-up photo from directly in front of the detail, and then from an angle to show the depth of the carving are desirable. Special details are usually found behind the saddle, on the side of the rump, or on the shoulder and chest of the animal. Sometimes, the head or mane are especially detailed. If this is the case, you should have several photos taken from different angles of these areas to show the depth and angle of the original carving. (See Figure 113 on the following page.)

Normally, a roll of 24 photographs is more than enough to make adequate photos of your intended model.

figure 113: Normally, a roll of 24 photographs is enough!

Just remember that if you can't see something in the photographs when you get home, you can't carve your figure right. Take whatever views you need to get all the details right.

GETTING THE PATTERN ON PAPER

There are many ways to transfer your photograph to a pattern size that you want to work with. I use a machine similar to an overhead projector and simply change the setting to adjust the pattern size. These machines are expensive, but I sometimes make several patterns a week, so it is effective for me to have my own equipment.

If you use slide film for the pattern shot, a slide projector focused on a piece of paper taped on the wall will give you an image you can draw around. Be sure you do not elevate the projector or you will be introducing even more distortion into your drawing. The projector must be focused at a 90 degree angle from the paper you are drawing on. Using slides and a projector is the best system I know of to make a *full-size carousel pattern*, should you ever want to do a large carving.

The simplest way we have today to make a pattern is to use a duplicating machine that will enlarge your photos on copy paper to the final size you want. Then, using tracing paper over

82

the copy, draw your pattern and make the adjustments to correct for distortion.

You can also use a pantograph (a technique I never cared for), or the grid method (which involves scaling up a pattern by drawing a grid over it and then drawing what appears on that grid onto a larger sized grid, thus reproducing the pattern square by square). Both of these methods seem to have too many inaccuracies inherent in them for my taste. But if it works for you —- go for it.

I work very hard to make my patterns as close to the real carousel figures as I possibly can. I always work from my photographs to start. It is a good idea to get the measurements of the length of the body to set your scale to. I use 1 1/2 inches to 1 foot (1 1/2":1') scale for my miniatures. For instance, if the length of the body of the real carousel horse is 3 feet 1 inches, I will draw my pattern with the body 4 5/8 inches long. If you do this as you carve all of your carousel figures, you will get the correct proportions for all of your pieces. Some will be larger than others, but that is because some of the actual carousel animals are larger than others.

The patterns in this book are all drawn 1 1/2 inches to the foot. You can enlarge them or decrease them in size to fit your own preferences and needs. All of these patterns were made from actual photographs of real carousel horses, following the procedures just as I have described above.

Chapter 16

LEARNING MORE ABOUT CAROUSELS

Carousels are fascinating subjects to study. The history of the development of the carousel industry includes many mysteries that carousel lovers are still trying to unravel. The American carousel is an integral part of the development and the evolution of industry in our country.

In a time span of about 60 years, the American carousel companies became known as the best anywhere. No other companies in the world could compete with the beautiful carvings on the carousels carved here, especially during the later years of the era. They evolved into the best through competition with other companies. Each manufacturer was trying to be better than his competitors. The carvers were allowed a freedom of expression and idea that was not allowed in the competing carousel carving shops in Europe. Consequently, the ornate carving on American carousel figures is unequalled anywhere.

Carousels developed into what is now known as three basic styles: the country fair style, the Philadelphia style, and the Coney Island style. The patterns featured in this book illustrate the country fair style of carving. Later books will illustrate the other styles of carving. Each style had a particular look and purpose.

The Philadelphia style was originally started by Gustav Dentzel and featured very ornately carved figures with rather classic looks. Most animals of this type were built for large permanent machines and placed in amusement parks, city parks, and sometimes on amusement piers.

The Coney Island type was created by Charles Looff and was a more flamboyant style, with much more flash and glitter. This style of carousel competed primarily with the Philadelphia style in the market of larger carousels. Carousel figures carved in this style usually were decorated with many glass jewels, mirrors, and gold leaf overlays. Charles Looff had special jewels made just for his figures and had a "starburst" cut into the center of each of them to add even more glitter. M.C. Illions also carved in the Coney Island style, and his horses were reknowned for their swirling goldleaf manes.

Carousel factories sprang up here and there all over the country. Some produced only a few carousels and then went out of business. Probably, there were some that we are not even aware of today that some eager historian may find some day in the future. Only the best companies survived. As they competed with each other for orders, they were constantly working toward building a better product. And they did it. Very few industries ever produced a product that continues to operate almost trouble-free for 100 years after it was first produced.

The carousel mechanism is an amazing study in simplicity. It was engineered in a time without computers. All of the weight is suspended from a single center pole. A carousel sways and dips as the load changes and riders load and unload. Yet, it remains perfectly balanced; the gears, drive shafts, and crank shafts operate in a beautiful symphony of movement as the carousel flashes and spins. A band organ adds to the beauty of the movement with its characteristic sound.

The band organs that were built for those fantastic carousels deserve their own books. They were as intricate as the carousel them-

selves and played the beautiful and familiar waltzes, marches, and classical music of the times. The carving on the exterior of some of those band organs was just as beautiful and intricate as that on the the carousels. Some even featured carved wooden figures that moved to play small instruments or lead the band.

Whatever feature attracts you: the history, the mechanism, the carved horses and figures, the band organs, or the exhilaration of the ride itself, there is something about a carousel that will prove fascinating for everyone.

Some of you may be lucky enough to have a carousel near you. Go see it! Ride it! Put your fingers in the gouge marks and cuts made by a fellow woodcarver almost a century ago. Study the way the figure was built and carved. Notice the way the carver solved the problems of carving and created the illusion of a real horse from a few pieces of wood. They used a lot of tricks in their work. See if you can discover a few of them.

Sometimes, those carvers made mistakes too. It is my own particular quirk to see how many of them I can find. I have found straps that don't do anything or which go under a mane and don't come back out. There is a poor third row horse on the Philadelphia Toboggan Company carousel at Six Flags Over Mid-America near St. Louis that looks as if it either ran into a brick wall or is the result of cross breeding with an elephant seal. My favorite mistakes, though, can be found on Dentzel machines. Many of these mistakes occurred in their original design and the horses continued to be produced with the same mistakes, each time the figures were produced. One Dentzel stander has a leg shorter than the other three —- it is always shorter. But my absolute favorite mistake is in the Dentzel ostrich. It is a running bird with one leg stretched forward, and the other back. The saddle cinch goes down

between the legs —- ahead of one —- and behind the other. I would like to see that ostrich really try to run!

There are many good carousel groups you can join. Some carousels have support groups that work with and/or on a particular carousel. They raise money for up-keep and sometimes are even involved in the upkeep itself. Some states have their own carousel support groups or organizations.

There are also two large national carousel organizations that hold conventions. The National Carousel Association has an annual convention in a different location every year, and affords plenty of opportunities to photograph, study, and ride different carousels as well as to learn more in seminars. They also have an NCA Technical Conference each year for anyone interested in getting into the nitty gritty of carousel operation, preservation, restoration, and maintenance. The NCA is dedicated to the preservation of the few remaining wooden carousels still existing in this country and it works very hard toward that end. (At this time, there are only about 160 wooden carousels left from the thousands that were originally built.) They also put out a quarterly magazine all about carousels, carousel events, and historical information. They compile an annual census of carousels, giving the location of each, as well as road directions on how to locate each one by state, and including the days and hours of operation. A contact telephone number is often included.

Each year, I have the honor of carving a miniature replica of a carousel figure from a different carousel for the National Carousel Association Collection. A mold is made from the carving, and 1,000 numbered limited edition castings are made. Each of the figures is hand-painted in the authentic colors of the original animal on the carousel. These figures are sold through the NCA to individuals and gift

shops across the country. All of the profits from these sales go into the NCA Preservation Fund. The money is then donated to any struggling carousel that needs help to keep operating or to defray the costs of restoration. Those interested in the National Carousel Association Collection should write to the NCA for information and brochures.

The American Carousel Society also has an annual convention in a different location than that of the NCA. Again, the opportunity to ride and photograph carousels and to learn more

about the figures that appear on them through lectures is available to all attendees. This organization also produces a census and has an annual publication reporting on its convention.

A magazine, The Carousel News and Trader, is also available on a monthly basis. It includes many informative articles and photographs of carousels and provides information on carousel events and sources of supply for collectors, restorers, etc.

A list of organizations and carousel print material follows.

THE NATIONAL CAROUSEL ASSOCIATION
P.O. Box 4333
Evansville, IN 47724-0333
Dues: $30 per household

THE AMERICAN CAROUSEL SOCIETY
3845 Telegraph Road
Elkton, MD 21921-2442
Dues: $25

THE CAROUSEL NEWS AND TRADER
87 Park Avenue West, Suite 206
Mansfield, OH 44902-1630
Subscription Fee: $25

THE NATIONAL WOOD CARVERS
ASSOCIATION
7424 Miami Avenue
Cincinnati, OH 45243
Subscription Fee: $11

REFERENCE BOOKS
Hardcover

A Pictorial History of the Carousel by Frederick Fried
The Art of the Carousel by Charlotte Dinger
The Carousel Animal by Tobin Fraley
Fairground Art by Geoff Weedon and Richard Ward
Painted Ponies by William Manns, Peggy Shank, & Marianne Stevens
Grab The Brass Ring by Anne Hinds
The Great American Carousel by Tobin Fraley

Paperback

C.W. Parker, The Carnival King by Bob Goldsack
Abilene's Carousel by Cecilia Harris
The Carousels of the Philadelphia Toboggan Company by Charles Jacques (Editor of *Amusement Park Journal*)